# KNIVES
# & INK

# KNIVES & INK

## CHEFS and THE STORIES BEHIND THEIR TATTOOS (with RECIPES)

## ISAAC FITZGERALD     WENDY MacNAUGHTON

BLOOMSBURY

NEW YORK · LONDON · OXFORD · NEW DELHI · SYDNEY

Bloomsbury USA
An imprint of Bloomsbury Publishing Plc

1385 Broadway      50 Bedford Square
New York      London
NY 10018      WC1B 3DP
USA      UK

www.bloomsbury.com

BLOOMSBURY and the Diana logo are trademarks
of Bloomsbury Publishing Plc

First published 2016
© Isaac Fitzgerald & Wendy MacNaughton, 2016

ISBN: HB: 978-1-63286-121-4
EPUB: 978-1-63286-122-1

LIBRARY OF CONGRESS CATALOGING-IN-PUBLICATION DATA

Names: Fitzgerald, Isaac, editor. | MacNaughton, Wendy, illustrator.
Title: Knives & ink : chefs and the stories behind their tattoos /
[edited by] Isaac Fitzgerald and Wendy MacNaughton.
Other titles: Knives and ink
Description: New York : Bloomsbury, USA, an imprint of Bloomsbury Publishing, Plc, [2016]
Identifiers: LCCN 2016002299| ISBN 978-1-63286-121-4 (hardcover) | ISBN 978-1-63286-122-1 (ePub)
Subjects: LCSH: Cooks—United States—Anecdotes. | Tattooed people—United States—Anecdotes.
Classification: LCC TX649.A1 K575 2016 | DDC 641.5092/2—dc23 LC
record available at http://lccn.loc.gov/2016002299

2 4 6 8 10 9 7 5 3 1

Designed by Katya Mezhibovskaya
Printed and bound by in China by C & C Offset Printing Co Ltd

FOR
ALICE SOLA KIM
and
CAROLINE PAUL

# CONTENTS

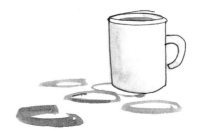

My mother can't cook. She showed her love in many ways, but food was not one of them. This made for a childhood of pasta and Chef Boyardee and vegetables straight from the can. By the time I was out of the house, the only trick I had learned in the kitchen was how to pour milk on cereal and, if I really wanted to go all out, mix peanut butter with vanilla ice cream.

I worked in numerous restaurants as a teenager and in my twenties. Sometimes as a dishwasher, usually as a waiter, but never as a cook. The kitchen was an explosive place, filled with heat and noise and chefs who were happy to do shots after work but on the job only wanted you to get your orders right, pick up your food fast, and get the hell out of their way.

Only once did I ever dabble in the culinary arts. For a short period when I was twenty-five, I was the world's worst sushi chef. Every morning, I'd rise early with the sun and ride my old, rusted Huffy through the South of Market neighborhood in San Francisco until I got to the prep kitchen in the back of a large warehouse. My boss was a skilled chef with over a decade of training in the art of sushi, and he was starting his own catering company. We would roll maki, cut sashimi, build nigiri, and place it all carefully into plastic boxes for the Palo Alto tech kids. It was incredible how patient my boss was with me, waiting calmly as my clumsy, unskilled hands formed the sushi rolls in slow motion. I always finished last, lucky not to have cut myself with the sharp Japanese knife he'd lent me.

So, to put it bluntly, cooking is not a skill I ever acquired. Thanks to my old boss's training I could probably make a shiro maguro roll if you gave me an hour but in my kitchen, it's still mostly cereal and peanut butter mixed with vanilla ice cream. Which is why the world of food fascinates me. The ability to make an exquisite dish out of dead animal flesh or plants grown in the dirt—whether it's a comforting, familiar reenactment of a favorite culinary memory, or full of strange and wonderful tastes that you're experiencing for the first time in your life—is nothing short of a miracle. It is an alchemy that I will never grasp.

Not only are chefs total badasses, they also look like total badasses—almost every chef I ever worked with was covered in tattoos. What is it about chefs and tattoos? Whether you're looking in a backwoods diner or a Michelin-starred eatery, it's hard

to find a cook who doesn't sport some ink. A lot of chefs get a tattoo because they see it as a commitment to the craft. A neck tattoo or a hand tattoo—or maybe even a tattoo atop your head—is a way of ensuring that you'll never work a desk job again. Others get tattoos for the reasons so many of us get them, to remember a moment, or a person, to carry something with us for the rest of our lives. Still others get them for possibly the best reason of all: just for kicks. Wendy MacNaughton and I have attempted to portray these tattoos, some food-related and some not, as the beautiful works of art they are, and to share the fascinating personal stories behind them.

The tattoo stories in this book come from chefs from all across the country. Some went to culinary school, others apprenticed, and still others were self-taught. Whether their stories are about cooking or their personal lives, all of the tellers are straight-up magicians who have mastered the art of making food. In addition to stories, some of the chefs have shared favorite recipes for you to try your hand at—from the complex, like Brown-Butter Sage Salmon with Gemelli Pasta, to the more simple to prepare (I myself plan on starting with the oatmeal). These recipes complement their stories, adding another dimension to a portrait of a chef.

Another skill I never mastered was drawing. Wendy MacNaughton's gorgeous illustrations perfectly capture the beauty, power, and pure radness of these chefs' tattoos. In her line work, you can perceive a devotion to art that mirrors the chefs' devotion to food and that celebrates the original tattoo artists' work. By presenting the tattoo as a drawing instead of a photograph, we're hoping you'll slow down a little bit and pay closer attention to images and details we might not normally look as closely at, or even see at all.

Drawing, cooking, telling stories, tattooing and being tattooed—there are so many different ways to express oneself creatively in this world. We hope you enjoy this glimpse into the ways these chefs do exactly that.

—ISAAC FITZGERALD
NEW YORK

# KNIVES
# & INK

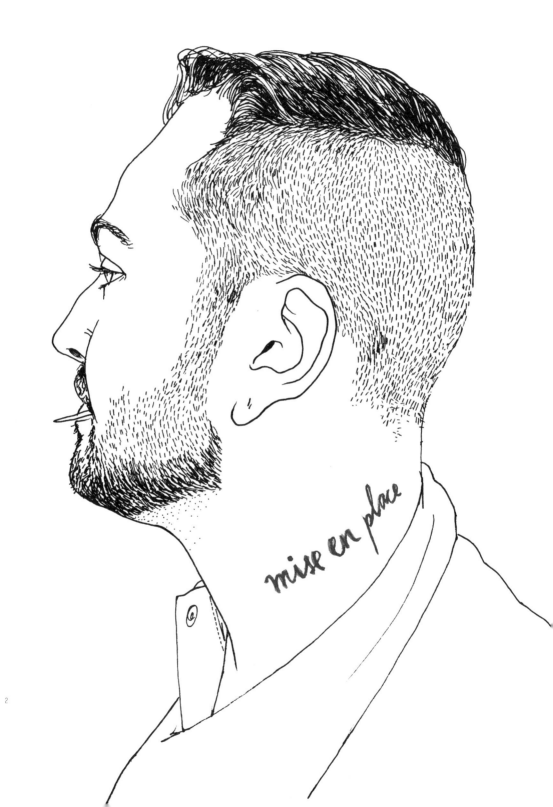

mise en place

# JOE TOMASZAK

ON MY NECK I'VE GOT "MISE EN PLACE,"
WHICH ROUGHLY TRANSLATES TO "EVERYTHING
IN PLACE," AN OLD MOTTO DRILLED INTO
EVERY COOK'S BRAIN, WHETHER AT SCHOOL OR
IN THE FIELD, FROM THE MOMENT YOU
PICK UP A KNIFE. IN A NUTSHELL, BEFORE
YOU START SERVICE, YOU NEED TO HAVE
ALL YOUR BITS and PIECES, THAT TOGETHER
MAKE A DISH, READY TO GO: YOUR DICED
TOMATOES, YOUR MOTHER SAUCES, YOUR
SEASONINGS, ETC. IT'S A CONCEPT THAT I
STRIVE TO APPLY IN MY DAY-TO-DAY LIFE
AS WELL. A DEDICATION TO STAYING
ORGANIZED and KEEPING EVERYTHING
IN ITS PLACE.

SUSHI CHEF
AT ICHI SUSHI + NI BAR
SAN FRANCISCO, CALIFORNIA

# BRIAN GROSZ

MY GRANDFATHER RAISED MY DAD IN
YOKOHAMA BEFORE THE FAMILY MOVED TO
WASHINGTON HEIGHTS. THEY WERE GAIJIN,
BUT JAPANESE ART WAS OMNIPRESENT
IN MY CHILDHOOD. NOW, IT'S OMNIPRESENT
ON MY BODY. COOKING IS ONE of THE
MOST BEAUTIFUL GIFTS YOU CAN GIVE TO
SOMEONE. IT EMBODIES LOVE, PATIENCE,
and BALANCE. PLATING, TOO, IS TANTAMOUNT,
JUST AS IMPORTANT AS THE PERMANENT
PLACEMENT of A TATTOO. ONE MUST MAKE
THE FOOD LOOK BEAUTIFUL (EVEN IF YOU'LL
JUST SHIT IT OUT IN THE MORNING).

PRIVATE CHEF
AND COOKING INSTRUCTOR
AT RONIN COOKING
BROOKLYN, NY

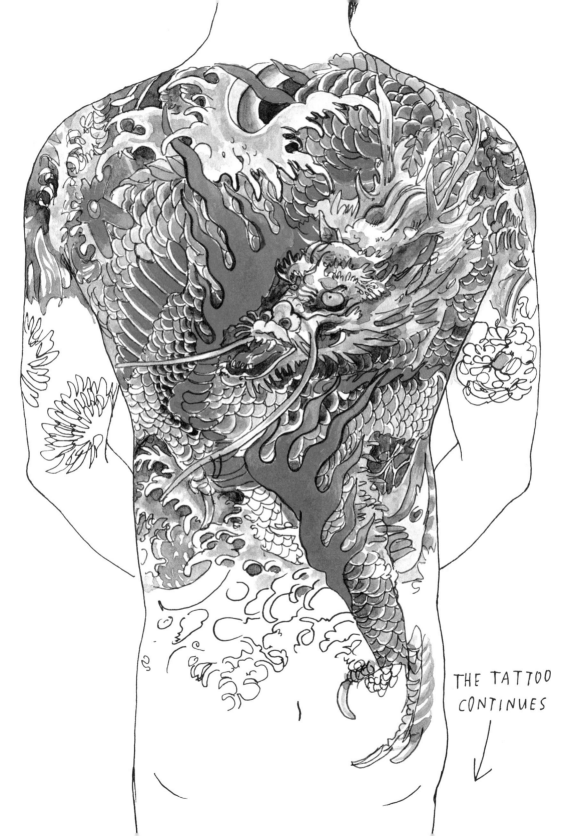

THE TATTOO CONTINUES

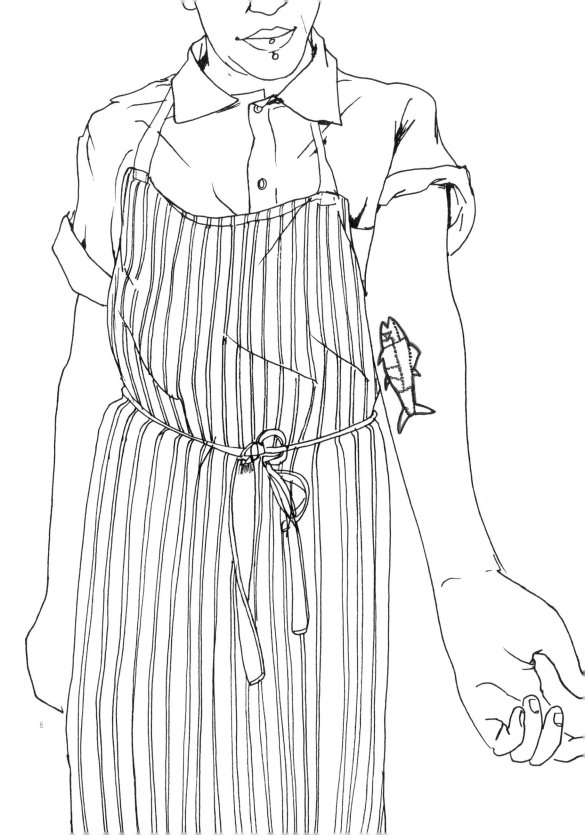

# ALISON RIVERA

WHEN YOU'RE BREAKING DOWN A PIECE of FISH, OR ANY KIND of MEAT, YOU WANT TO KNOW HOW MANY POSSIBLE CUTS YOU CAN GET OUT of IT. SO I DECIDED IF I JUST HAD THE GRID PERMANENTLY DRAWN ON MY ARM, LIFE WOULD BE SORTED.

CHEF
AT MISSION CANTINA
NEW YORK CITY, NEW YORK

# TIMMY MALLOY

I WAS NOT THE SMARTEST KID IN SCHOOL. I COULDN'T SIT STILL and WAS BASICALLY AN ADD POSTER CHILD, WHICH MADE THINGS TOUGH GROWING UP. BUT WHEN I FOUND COOKING, MY WHOLE LIFE CHANGED. I SAID, "SO WAIT, YOU ACTUALLY WANT ME TO BE DOING THIRTY THINGS AT ONCE? AND PLAY WITH FIRE and KNIVES?" I COULDN'T BELIEVE HOW PERFECT IT WAS for ME. BUT EVEN COOKING DIDN'T COME EASY TO ME—I HAD TO WORK VERY HARD for EVERYTHING I'VE EVER GOTTEN.

THIS IS A DIFFICULT INDUSTRY, EVEN THOUGH IT'S GLAMORIZED THESE DAYS. BEING ON YOUR FEET TEN TO  SIXTEEN HOURS A DAY. CONSTANTLY GETTING CUTS and BURNS. THE STRESS of SUCH A FAST-PACED ENVIRONMENT. AND, of COURSE, DEALING with CUSTOMERS— THE ONES WHO JUST DON'T UNDERSTAND WHAT IT TAKES, and HOW MUCH WE PUT INTO EVERYTHING WE DO. IT DOES A NUMBER ON YOU BOTH PHYSICALLY and MENTALLY. BUT THAT'S JUST THE BASIC EVERYDAY LIFE of A CHEF.

I'VE BEEN DOING THIS SINCE I WAS FIFTEEN YEARS OLD. THESE DAYS, THE KITCHEN IS A MUCH NICER PLACE TO WORK, BUT BACK WHEN I WAS STARTING,... CONTINUED ON NEXT PAGE

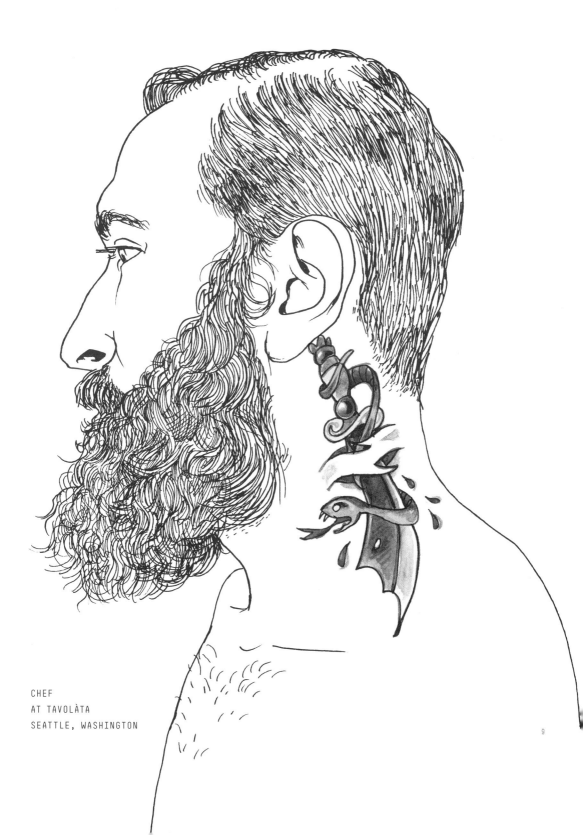

CHEF
AT TAVOLÀTA
SEATTLE, WASHINGTON

...CONTINUED FROM PREVIOUS PAGE THERE WERE STILL A LOT of THE OLD-SCHOOL CHEFS and COOKS OUT THERE WHO REALLY YELLED, THREW THINGS, and BASICALLY TREATED YOU LIKE A PIECE OF SHIT UNTIL YOU PROVED YOU WERE WORTHY.

FOR THE PAST TEN YEARS OR SO I'VE HAD A REALLY HARD TIME FINDING MY PLACE. I WENT FROM NEW YORK TO A NOWHERE TOWN IN PENNSYLVANIA TO WASHINGTON, D.C., TO SAN FRANCISCO TO NEW YORK CITY THEN BACK TO SAN FRANCISCO and NOW I'M IN SEATTLE. IN SOME WAYS, IT'S BEEN GREAT—I'VE MADE HUNDREDS of FRIENDS AND LEARNED A TON. BUT I ALSO FEEL LIKE I HAVEN'T REALLY EVER MADE ONE PLACE MY HOME.

THE YEAR 2014 WAS ONE of THE MOST WHIRLWIND YEARS of MY LIFE. I TURNED THIRTY, I LOST TWO GRANDPARENTS, and JUST ONE MONTH BEFORE IT WAS ANNOUNCED THAT I WAS ONE of SAN FRANCISCO'S

RISING STAR CHEFS, I LOST MY FATHER. THEN AT THE END of THE YEAR, THE RESTAURANT WHERE I WAS CHEF CLOSED.

IN MY SNAKE and DAGGER TATTOO, THE DAGGER REPRESENTS THE FIGHT, WHETHER THAT MEANS JUST GETTING THROUGH A FOURTEEN-DAY STRETCH of FOURTEEN-HOUR DAYS IN A 100-DEGREE KITCHEN, OR LOSING A LOVED ONE OR THE RESTAURANT THAT YOU LOVE and PUT SO MUCH INTO.

YOU HAVE TO FIGHT THROUGH IT; YOU JUST HAVE TO.
THE SNAKE REPRESENTS THE CYCLE, and HOW THINGS
IN LIFE REPEAT and RETURN IN DIFFERENT WAYS.
TO ME, THEY BOTH MEAN THAT LIFE IS A CONSTANT
FIGHT, BUT MAKING IT THROUGH THAT FIGHT MAKES
YOU STRONGER and HELPS
YOU ENJOY WHAT YOU HAVE.

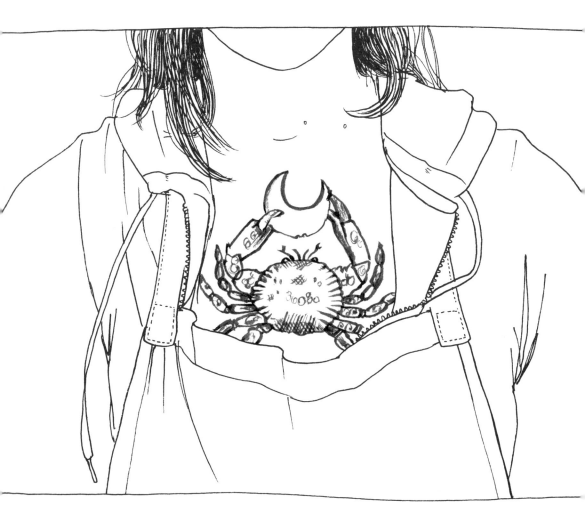

EXECUTIVE CHEF
AT NORTH LIGHT
PORTLAND, OREGON

# SOLEIL HO

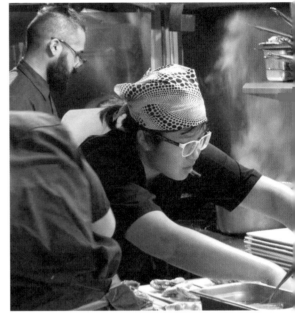

THIS TATTOO IS SOMETHING I'D PLANNED for A LONG TIME. I LOVE IT BECAUSE IT SIGNIFIES A LOT of THINGS: MY LOVE of GREAT INGREDIENTS, THE RESOURCEFULNESS of MY ANCESTORS, and THE PATH THAT I CHOSE for MYSELF, BOTH ARTISTICALLY and PROFESSIONALLY. IT'S A PADDY CRAB, WHICH IS A CLASSIC VIETNAMESE INGREDIENT. THE CRAB IS A PEST TO RICE FARMERS IN VIETNAM, BUT ALSO SERVES AS AN IMMEDIATE SOURCE of WILD PROTEIN FOR THEM. THEY EAT IT FRIED, BOILED, and EVEN USE FERMENTED CRAB AS A CONDIMENT IN GREEN PAPAYA SALAD. IT'S IMPORTANT TO ME TO REMEMBER WHERE I CAME FROM, and THE HUMBLE FOOD THAT STILL SUSTAINS and SATISFIES PEOPLE EVERYWHERE.

# MANDY LAMB

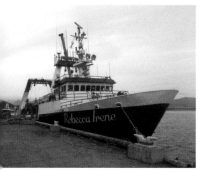

FOR THE PAST SEVEN YEARS I'VE
BEEN COOKING AT SEA. THIS
TATTOO IS A SIMPLE REMINDER
FROM MY FIRST BOAT. FOR
ME IT MOSTLY SYMBOLIZES
A PAINFUL LESSON: DON'T FALL IN
LOVE *with* THE CAPTAIN.

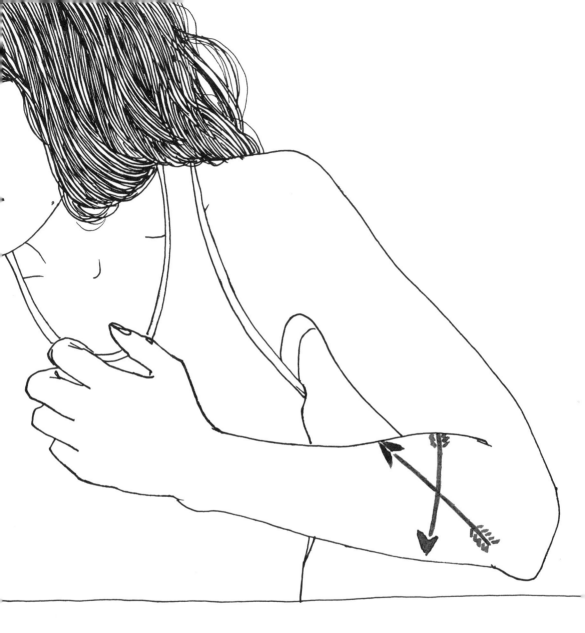

HEAD COOK
FV *REBECCA IRENE*
DUTCH HARBOR, ALASKA

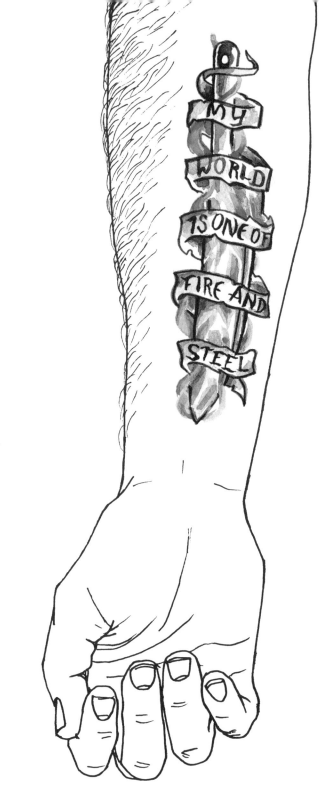

SOUS CHEF
AT ROCKIT BAR & GRILL
CHICAGO, ILLINOIS

# WILLIAM J. HASKINS

AFTER I CAME BACK FROM A DEPLOYMENT IN AFGHANISTAN IN 2009, MY MOTHER'S PARTNER GOT ME A TATTOO AS A WELCOME-HOME GIFT. THE TATTOO ARTIST WAS A FRIEND OF THE FAMILY WHO HAD DONE SOME PIECES FOR MY SIBLINGS AND MY PARENTS. HE HAD ALSO BEAT CANCER A FEW YEARS EARLIER, AND I KNEW I WANTED HIM TO BE THE ONE TO TATTOO ME. AS IT WAS MY FIRST, I WANTED SOMETHING COMPLETELY ORIGINAL, SOMETHING I'D NEVER SEEN ELSEWHERE. ALSO, I WANTED IT TO HAVE GERMAN LETTERING AS A NOD TO MY HERITAGE. THE ARTIST HAD TO BREAK IT TO ME THAT THE CHEF'S KNIFE AND FIRE, REPRESENTING MY LIFE IN THE KITCHEN, SURROUNDED BY GERMAN WORDS, MIGHT NOT BE SUCH A GREAT IDEA FOR A BIG GUY WHO TENDS TO KEEP HIS HAIR SHORT. IT TOOK ME A MINUTE OR TWO TO REALIZE WHAT HE WAS TALKING ABOUT, AS THE THOUGHT NEVER EVEN CROSSED MY MIND WHILE I WAS DRAWING IT. GUESS I WAS STILL INNOCENT IN SOME WAYS. AFTER SOME DISCUSSION AND A FEW SKETCHES, WE CAME UP WITH THIS TATTOO. A FEW HOURS, SOME WHISKEY, AND A FEW GOOD STORIES LATER, IT WAS DONE. I ENJOY IT TREMENDOUSLY AND WEAR IT WITH PRIDE.

# JOHN PRESCOTT'S HONEYED RICOTTA with CARROT CONFIT and CARROT-TOP SALAD

*For the ricotta*
2 QUARTS WHOLE MILK
1 PINT HALF & HALF
LARGE PINCH OF SALT
¼ CUP FRESH MEYER LEMON JUICE (REGULAR LEMON JUICE IS FINE AS WELL)
¼ CUP SOURWOOD HONEY PLUS MORE FOR GARNISH (OR ANOTHER GOOD-QUALITY RAW,
   UNFILTERED HONEY)

Bring dairy and salt to a boil, then remove from heat. Add lemon juice and stir until incorporated. Let mixture sit 5 minutes. Strain through a cheesecloth-lined chinois to separate curds and whey. Reserve whey for future use (it has many uses and is delicious when reduced to a caramel-like consistency). Let curds rest in chinois for 30 minutes to become fairly firm.

Place in container and refrigerate for 1 hour. Remove from fridge and stir in honey; place back in fridge until ready to use.

*For the carrot confit*
2 POUNDS FRESH, ORGANIC CARROTS WITH TOPS STILL ATTACHED (THE GREEN LEAFY PARTS)
4 CUPS OLIVE OIL (YOU DON'T NECESSARILY NEED AN EXTREMELY HIGH-QUALITY
   EXTRA-VIRGIN KIND)
1 TABLESPOON PLUS 1 TEASPOON SEA SALT
1 TABLESPOON CARDAMOM PODS (IF YOU CAN'T FIND PODS,
   SUBSTITUTE ¼ TABLESPOON GROUND CARDAMOM)
½ TABLESPOON RED-WINE VINEGAR

Cut tops off carrots and reserve for later. Peel carrots. Slice carrots lengthwise. Toss carrots with 1 tablespoon sea salt and the cardamom. Heat olive oil until warm, not hot, and place carrots in oil. Cook carrots on very low heat. You do not want to fry carrots, just gently cook them. Cook for 1 hour or until they are soft but still have a firmness to them. Let cool completely in oil. Pour into container, making sure to cover carrots with oil (you can reuse the oil for more confit or it also makes a great vinaigrette), and refrigerate until ready to use.

*To finish the dish*
With a spoon, smear some honey on a plate, make a quenelle of the ricotta cheese, and place on honey. Take carrots out of oil and pat oil off of them. Lean carrots on ricotta. Chop reserved carrot tops and toss with red-wine vinegar, 1 teaspoon sea salt, and a little of the reserved carrot oil. Garnish ricotta and carrots with carrot-top greens. Enjoy.

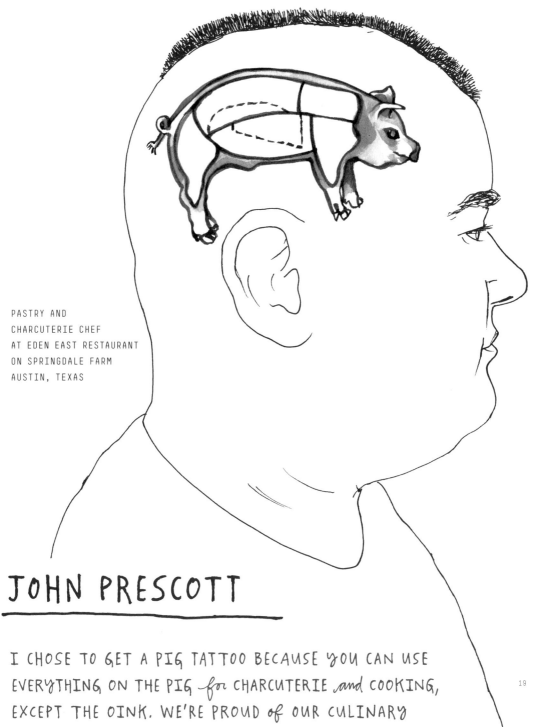

PASTRY AND
CHARCUTERIE CHEF
AT EDEN EAST RESTAURANT
ON SPRINGDALE FARM
AUSTIN, TEXAS

# JOHN PRESCOTT

I CHOSE TO GET A PIG TATTOO BECAUSE YOU CAN USE
EVERYTHING ON THE PIG *for* CHARCUTERIE *and* COOKING,
EXCEPT THE OINK. WE'RE PROUD *of* OUR CULINARY
COMMUNITY HERE IN AUSTIN. TO US, THE PIG IS SACRED.

# DOMINIQUE CRENN

A FEW YEARS AGO I HAD AN ACCIDENT. A VERY SCARY ONE.
I WAS A HOTEL CHEF AT THE TIME, WORKING SEVEN DAYS A WEEK.
I CAME HOME VERY LATE FROM WORK ONE NIGHT, EXHAUSTED,
and WHILE I WAS IN THE SHOWER I SLIPPED and SLICED A TENDON
IN MY LEG WIDE OPEN. I LOST CONSCIOUSNESS for FIFTEEN,
TWENTY MINUTES. WHEN I CAME TO, BLOOD WAS EVERYWHERE. I
COULD HAVE LOST MY LIFE, BUT SOMEHOW I DIDN'T. I CALLED 911
and AN AMBULANCE ARRIVED BEFORE I BLED OUT. STILL, I WAS
BEDRIDDEN for THREE MONTHS. I COULDN'T MOVE. SO THIS TATTOO
REMINDS ME TO CELEBRATE THAT MOMENT IN MY LIFE: THE MOMENT
I LIVED. I WANTED SOMETHING THAT SPOKE TO THE MIX of
STRUGGLE and HOPE, DREAM and REALITY. IT'S ABOUT DOING
ANYTHING IN LIFE THAT YOU PUT YOUR HEART TO, KNOWING THAT
IT DOESN'T MATTER WHERE YOU ARE IN
YOUR LIFE. ANY MOMENT IS THE
RIGHT MOMENT, BECAUSE NONE of
US KNOW HOW MANY MOMENTS
WE HAVE LEFT.

OWNER OF AND CHEF
AT ATELIER CRENN AND PETIT CRENN
SAN FRANCISCO, CALIFORNIA

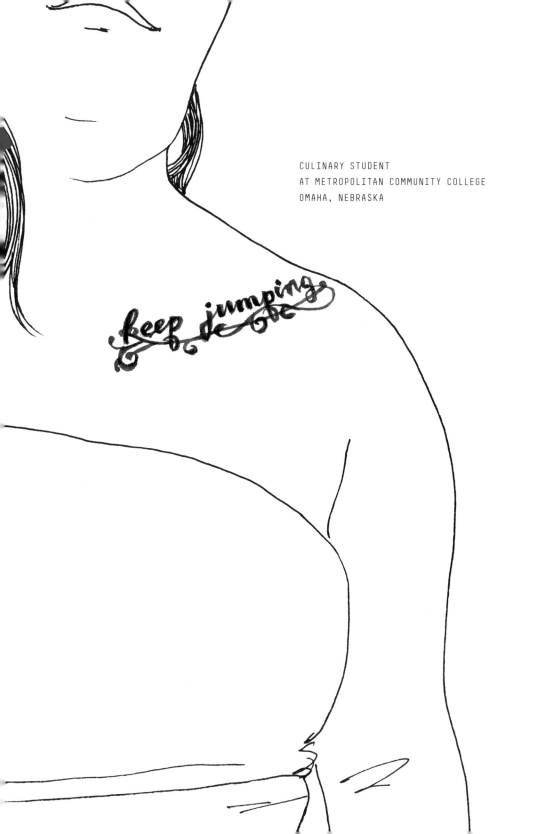

CULINARY STUDENT
AT METROPOLITAN COMMUNITY COLLEGE
OMAHA, NEBRASKA

# DEVIN WHITE

IN EARLY 2013, MY GRANDPA WAS DIAGNOSED with LUNG CANCER.
SADLY, IT WAS INOPERABLE and COULD ONLY BE TREATED with
CHEMOTHERAPY. HE REMAINED HEALTHY for A WHILE, BUT AS THE
CHEMO TOOK ITS TOLL, HIS CONDITION DETERIORATED. IT WAS
THEN THAT HE WAS HOSPITALIZED for THE FINAL TIME, THOUGH
HE FOUGHT LIKE HELL.

WHEN WE WENT TO SAY
GOOD-BYE, MANY OTHER FAMILY
MEMBERS WERE THERE AS WELL.
SINCE MY GRANDPA SEEMED TO BE
SLEEPING, WE ALL TALKED TO
EACH OTHER ABOUT RANDOM
THINGS, LIKE A RECENT ANKLE
INJURY I'D HAD. ALL TOO SOON, IT WAS TIME TO SAY MY FINAL
GOOD-BYE. AS I LEANED IN TO GIVE HIM ONE LAST HUG and KISS,
MY GRANDPA OPENED HIS EYES, LOOKED AT ME, and SAID SOMETHING
THAT WOULD NEVER, EVER LEAVE MY HEART. HE SAID, "KEEP
JUMPING." THOSE WERE HIS LAST WORDS TO ME, and I KNEW
EXACTLY WHAT THEY MEANT—DON'T GIVE UP, JUST BELIEVE
IN YOURSELF. TWO DAYS LATER HE PASSED AWAY. RIP, PAPA LES.
WHEN MY GRANDPA PASSED, I KNEW I WANTED HIS FINAL WORDS
TATTOOED ABOVE MY HEART. NOW WHEN I HAVE A BAD DAY OR THINGS
AREN'T GOING WELL, I JUST LOOK TO MY TATTOO and KNOW
EVERYTHING WILL BE OKAY.

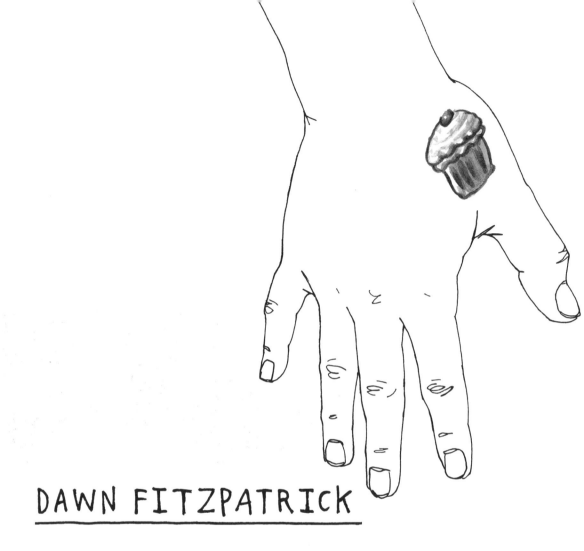

# DAWN FITZPATRICK

I WENT TO SCHOOL AT LE CORDON BLEU. A WEEK IN, I GOT MY
FIRST TATTOO: A CUPCAKE, WHICH ALSO BECAME MY KITCHEN NAME
for THE NEXT THREE YEARS. A YEAR AFTER MY FIRST TATTOO,
I GOT A PIECE of CAKE ON MY LEFT HAND. PEOPLE ASKED, "WHY?"
I ASKED, "WHY NOT?" I COULDN'T PICTURE THEM ANYWHERE
ELSE, and I'VE NEVER REGRETTED PUTTING DESSERTS WHERE I'D SEE
THEM EVERY DAY. EVEN THOUGH I HAVE LEFT THE INDUSTRY, MY
DESSERT TATTOOS ARE STILL A PART of ME, and I CAN'T IMAGINE
MY HANDS WITHOUT THEM.

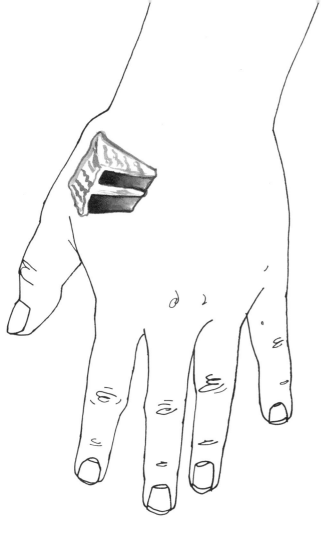

FORMER PASTRY COOK
AT TODD ENGLISH'S BLUEZOO
LAKE BUENA VISTA, FLORIDA

# TRAVIS MICHAEL WEISS

I'VE WRITTEN HUNDREDS of RECIPES and MENUS, BUT RIGHT NOW I'M IN THE MIDDLE of OPENING A RESTAURANT with A MENU THAT IS 100-PERCENT ME: MY CHOICES, MY DECISIONS. IT'S THE FIRST TIME I'VE BEEN GIVEN TOTAL CONTROL. SO JUST A COUPLE MONTHS AGO, AT AGE THIRTY-THREE, I WAS INSPIRED TO GET A TATTOO THAT HAS ALL THE INGREDIENTS THAT HAVE BEEN THERE WITH ME SINCE MY CHILDHOOD: BLUE CRABS, OLD BAY, SILVER QUEEN CORN, and LOTS of GREAT LOCAL PIGS. A LOT of PEOPLE ASK IF THEY CAN NAME THE PIG OR CRAB. THE PIG IS ALREADY NAMED DAISY. SHE WAS THE FIRST PIG I "HARVESTED," AKA BROKE DOWN and COOKED FROM BEGINNING TO END. BUT THE CRAB HASN'T BEEN NAMED YET. SO I'M STILL TAKING SUGGESTIONS.

## TRAVIS MICHAEL WEISS'S D.C. MUMBO SAUCE

1 QUART KETCHUP, HOMEMADE OR HEINZ
1 CUP GOOD-QUALITY HONEY
2 CUPS GRANULATED SUGAR
6 FLUID OUNCES PINEAPPLE JUICE
4 TABLESPOONS PAPRIKA
1½ CUPS KOLSCH OR SIMILAR LIGHT LAGER
1 CUP SRIRACHA

Simmer on medium heat for 20 to 25 minutes to reduce by 25 percent. Chill, enjoy.

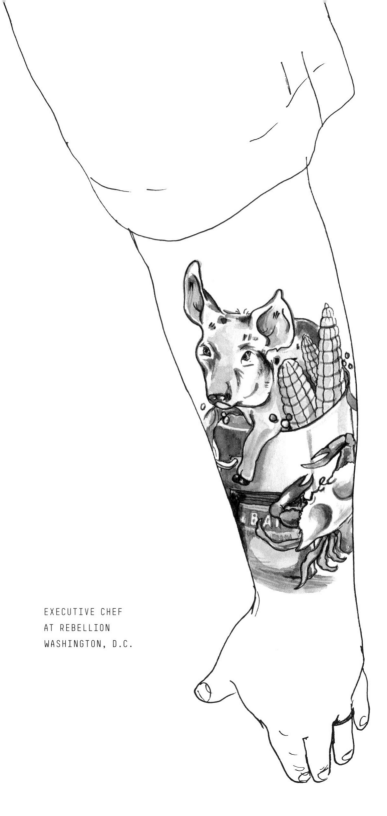

EXECUTIVE CHEF
AT REBELLION
WASHINGTON, D.C.

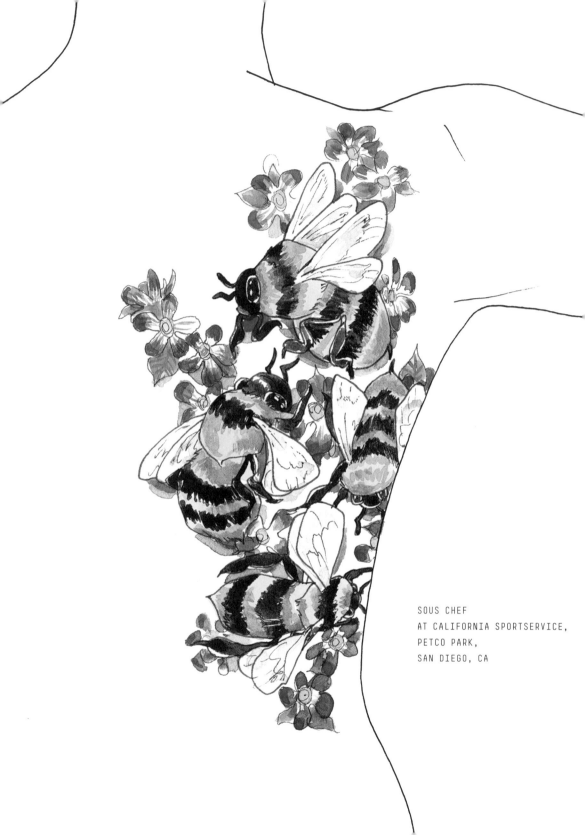

SOUS CHEF
AT CALIFORNIA SPORTSERVICE,
PETCO PARK,
SAN DIEGO, CA

# CATHERINE DOYLE

AT THE LARGE CORPORATION WHERE MY DAD WORKED, HE'D BEEN REQUIRED TO TAKE ALL SORTS of TRAINING COURSES: SAFETY AWARENESS, INTERNATIONAL TRAFFICKING IN ARMS REGULATIONS, CULTURAL AWARENESS, ETC. ONE DAY, AN AUTOMATED E-MAIL ALERTED HIM THAT HE WAS OVERDUE FOR BERYLLIUM AWARENESS TRAINING. IT WAS PROBABLY A MISTAKE, BUT IT SOUNDED SO GOOFY THAT HE TOOK THE COURSE. MY SISTER EMY FOUND THIS HILARIOUS. SHE'D SAY, "DAD, YOU MAY HAVE BEEN OFFENDING THE BERYLLIUM COMMUNITY for YEARS WITHOUT EVEN REALIZING IT. GOOD THING YOU FINALLY GOT THAT TRAINING." BERYLLIUM AWARENESS WAS A RUNNING JOKE BETWEEN THEM for MANY YEARS. DURING MY SISTER'S LAST CHRISTMAS, SHE FOUND A BERYLLIUM T-SHIRT SOMEWHERE and GAVE IT TO MY DAD AS A PRESENT. SHE DIED THREE MONTHS LATER FROM CANCER COMPLICATIONS.

MY DAD BROUGHT THE BERYLLIUM T-SHIRT with HIM WHEN HE HIKED THE APPALACHIAN TRAIL LAST SUMMER. ANOTHER HIKER SAW THE SHIRT'S ATOMIC NUMBER 4 and "BE" SYMBOL and SUGGESTED MY FATHER TAKE THE TRAIL NAMED "4BE." AFTER MY DAD FINALLY FINISHED THE TRAIL, I GOT A TATTOO of FOUR BEES, FOR BERYLLIUM, IN HONOR of HIM AND MY SISTER EMY.

# JENNY DORSEY

MY TATTOO IS PART of A QUOTE FROM THEODORE ROOSEVELT'S SPEECH "THE MAN IN THE ARENA" THAT REALLY STUCK with ME. IN SHORT, IT IS MORE IMPORTANT TO TRY and FAIL THAN TO NEVER TRY AT ALL. I NESTLED IT UNDERNEATH THE LOTUS FLOWER AS A SYMBOL for STRENGTH.

I DID NOT, HOWEVER, HAVE ANY IDEA AT THE TIME HOW IT WOULD APPLY TO MY FUTURE. I WAS A FINANCE MAJOR STARTING A GLITZY CONSULTING CAREER IN NYC. ON THE FAST TRACK and ABOUT TO GO TO BUSINESS SCHOOL, I WOKE UP and REALIZED I WAS MISERABLE. I MADE THE SCARY DECISION TO COMPLETELY CHANGE THE COURSE of MY LIFE and GO INTO THE CULINARY ARTS. MY PARENTS STILL BARELY TALK TO ME. BUT I LEARNED WHO MY REAL FRIENDS WERE IN THE PROCESS and MET MY ...CONTINUED ON NEXT PAGE

CHEF AND FOUNDER
OF THE I FORGOT IT'S WEDNESDAY SUPPER CLUB
NEW YORK CITY, NEW YORK

...CONTINUED FROM PREVIOUS PAGE NUMBER-ONE SUPPORTER (and NOW HUSBAND) TOO. DURING THAT TIME, I REALIZED THERE WAS A GOOD REASON I HAD GOTTEN THIS SPECIFIC TATTOO OVER TWO YEARS AGO, EVEN THOUGH I DIDN'T KNOW IT THEN. TODAY I FINALLY FEEL I AM STARTING TO GROW INTO THE PERSON I ALWAYS WANTED TO BE. I STILL REMIND MYSELF ALL THE TIME THAT IT TAKES COURAGE TO STEP OUTSIDE WHAT IS SAFE and KNOWN TO PURSUE WHAT YOU BELIEVE IN, WHAT YOU ARE PASSIONATE ABOUT. THERE WILL ALWAYS BE NAYSAYERS BUT UNTIL THEY STAND IN THAT ARENA WITH ME, THEY ARE COMPLETELY IRRELEVANT.

# JENNY DORSEY'S EARL-CHUAN PEPPER-GREY RUB

It's a 2:2:1 ratio of **LOOSE EARL GREY TEA**, **WHOLE SICHUAN PEPPERCORN**, and **WHOLE ALLSPICE** (in that order). Just grind until fine, then rub on all the meats! I usually serve it with duck breast alongside some ube puree but it's also great on pork!

ROBIN LAM OF MAKE THINGS WELL

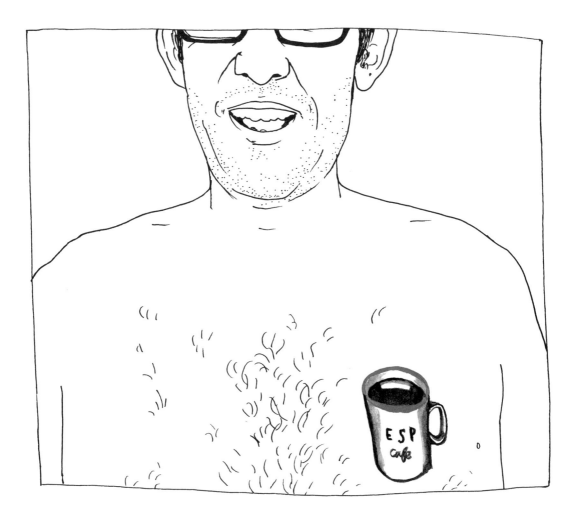

OWNER OF AND CHEF
AT PERFECT LITTLE BITES
CATERING SERVICE
FREDERICK, MARYLAND

# CHRIS SPEAR

THE FIRST REASON I GOT A COFFEE MUG
TATTOO IS THAT MY MOM COLLECTED COFFEE
MUGS—SHE'D PICK ONE UP FROM EVERY
PLACE SHE VISITED. MY MOM PASSED AWAY
A FEW YEARS AGO FROM A BRAIN TUMOR,
and THIS IS MY WAY of KEEPING A PIECE of
HER WITH ME ALWAYS OVER MY HEART.
THE MUG ALSO REPRESENTS SEATTLE, WHERE I
USED TO LIVE with MY WIFE, WHO RAN A
COFFEE SHOP THERE. ESP ARE MY WIFE'S INITIALS
for HER MAIDEN NAME. SHE'D ALWAYS
THOUGHT HER INITIALS WERE COOL, BUT THEY
CHANGED WHEN WE GOT MARRIED and SHE
TOOK MY NAME. SHE FELT LIKE SHE HAD LOST
A LITTLE SOMETHING. SO, SINCE MY WIFE
TOOK MY NAME, I THOUGHT IT'D
ONLY BE FAIR TO
COMMEMORATE
HERS.

# CHRIS SPEAR'S SMOKED GOUDA AND HOT PEPPER RELISH SPREAD

I have a pretty well-known love of pimento cheese. After years of adjustments, I feel like I finally have my recipe down. The next step was to make a series of cheese spreads that were loosely based on pimento cheese. Since I'm a sucker for smoked gouda, it seemed like the natural next step. The pimentos are replaced with hot pepper relish, my current sandwich condiment of choice. I like using pita chips to stand in for the traditional Ritz crackers. You could make your own, but Stacy's Simply Naked chips are easy and delicious.

1 POUND/455 GRAMS SMOKED GOUDA CHEESE, FINELY SHREDDED,
    BROWN EXTERIOR REMOVED
4 OUNCES/115 GRAMS CREAM CHEESE AT ROOM TEMPERATURE
½ CUP/125 GRAMS MAYONNAISE (DUKE'S OR HELLMANN'S)
1 TABLESPOON/27 GRAMS HOT PEPPER RELISH, PLUS MORE FOR SERVING
1 TEASPOON/8 GRAMS HOT SAUCE (FRANK'S RED HOT)
¼ TEASPOON/3 GRAMS SMOKED PAPRIKA, PLUS MORE FOR SERVING
½ TEASPOON/2 GRAMS SUGAR
¼ TEASPOON/2 GRAMS KOSHER SALT

Put Gouda and room temperature cream cheese in the bowl of an electric mixer and beat on medium-high for close to 5 minutes with the paddle attachment, stopping to scrape the bowl as needed. Add the remaining ingredients. Turn mixer on and slowly bring the speed up to medium. Mix for an additional 3 minutes, scraping as needed.

To serve, place the cheese spread in a serving bowl. Dust with smoked paprika and add more hot pepper relish on top.

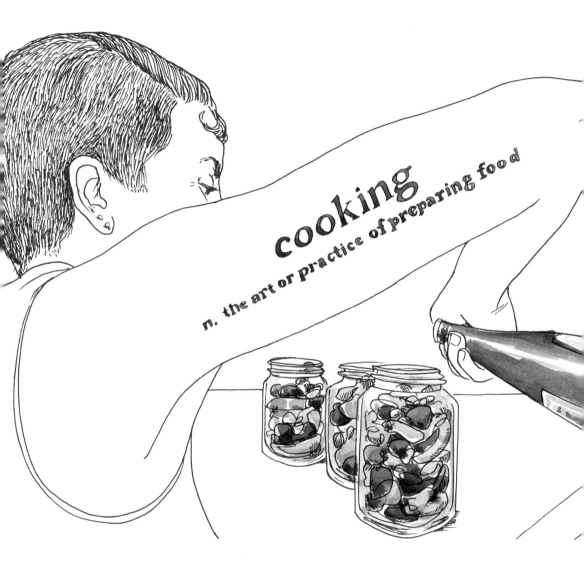

cooking

*n. the art or practice of preparing food*

CHEF AND HOST
AT BRITISH-THEMED POP-UPS
SAN FRANCISCO, CALIFORNIA

# MYSTICAL GREATRICK

MY SIX-YEAR-OLD SON HAD ASKED ME WHAT THE WORD "CHEF" MEANT, SO WE WENT TO THE DICTIONARY and STARTED READING. WHEN WE FOUND THE ENTRY for COOKING, HE SLOWLY READ IT ALOUD TO ME, SOUNDING OUT EACH CONSONANT. SIMPLE WORDS, HINTING AT GREAT POWER. IT REPRESENTED EXACTLY HOW I FELT ABOUT FOOD and COOKING. I HAD IT PLACED SOMEWHERE THAT HELD JUST AS MUCH WEIGHT— THE BACK of MY CHOPPING/WHISKING/MIXING/ FEELING ARM. I LOVE SEEING PEOPLE STARING AT MY ARM and TIPPING THEIR HEAD AS THEY TRY TO READ IT. WHEN I'M WORKING IT IS DISPLAYED PROMINENTLY, REMINDING EVERYONE WHY WE ARE HERE—for THE ART.

Here is a recipe of mine for a tasty and easy chicken pie using leftovers from a roast. The British are known for their Sunday roasts, and my family are partial to a roasted bird over any other meat so I came up with this throw-together on the Monday following one particular Sunday to use up the leftover meat from the chicken. So much meat is left over on the carcass after slicing and I'm not a fan of wasting, so this became our family go-to recipe for the days that followed a roast—although if I'm being honest, it's become so popular with my kids that sometimes I roast a bird just to shred it for this recipe. The prepared filling keeps wonderfully in the freezer also!

*Serves 6*

1 TABLESPOON VEGETABLE OIL
3 CUPS COOKED CHICKEN, SHREDDED
8 RASHERS SMOKED STREAKY BACON, CUT INTO LARGE PIECES
1 ONION, HALVED AND SLICED
1 CELERY STALK
2 LEEKS
250 GRAMS BABY BUTTON MUSHROOMS
1 TEASPOON SUMMER SAVORY
5 SPRIGS OF THYME
2 TABLESPOONS PLAIN FLOUR
1½ CUPS CHICKEN STOCK
1 CUP MILK
1 PACK OF PUFF PASTRY
1 EGG
SPLASH OF MILK

MYSTICAL GREATRICK'S CHICKEN, LEEK, and MUSHROOM PIE

Heat oil and add bacon to the pan. Fry for 5 minutes until crisp. Add the onion, celery, and leeks and fry for 3 minutes; add mushrooms, summer savory, and thyme; fry for a further 3 minutes until the onions start to color.

Tip the flour into the pan and cook, stirring, for 1 minute. With the pan off the heat, gradually whisk in the stock, followed by the milk, then add the chicken to the pan. Bring to boil, then simmer for 30 minutes. Spoon the filling into a large pie or baking dish with a lip (approximately 20 x 30 cm) and leave to cool.

Pre-heat oven to 400° F.

Whisk egg and milk together.

Once filling has cooled, top pie with puff crust and brush with a thin layer of egg wash. Bake for 30 minutes.

# ALEC SHERMAN

THIS TATTOO IS for MY DAUGHTER ROSE. WE LOST HER THIS YEAR AT TWENTY-FOUR WEEKS. SHE IS MY GUIDING LIGHT THROUGH MY LIFE AS A CHEF. THE TWO ROSES REPRESENT ME and MY WIFE. A SCALLOP SHELL for THE PILGRIMAGE. AN UPRIGHT HORSESHOE for GOOD LUCK. AND A STORM SCENE with A LIGHTHOUSE. THAT LIGHT PUSHES ME EVERY DAY. I KNOW IT WILL ALWAYS SHINE; IT WILL ALWAYS HELP ME GET WHERE I AM GOING. IT IS A LIGHT THAT WILL NEVER BURN OUT.

CHEF
AT SOUTHPORT & IRVING
CHICAGO, ILLINOIS

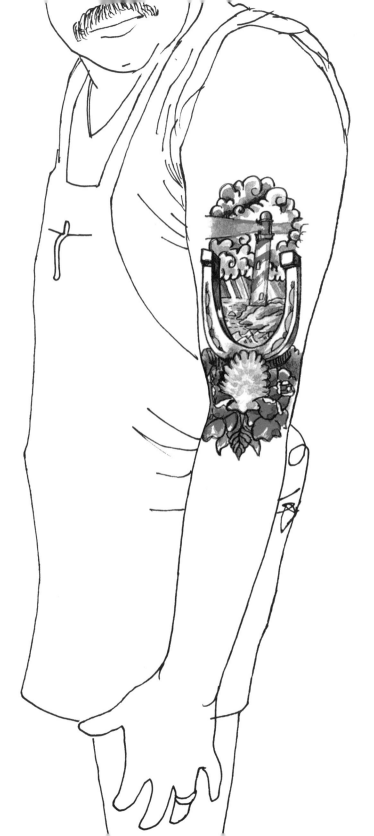

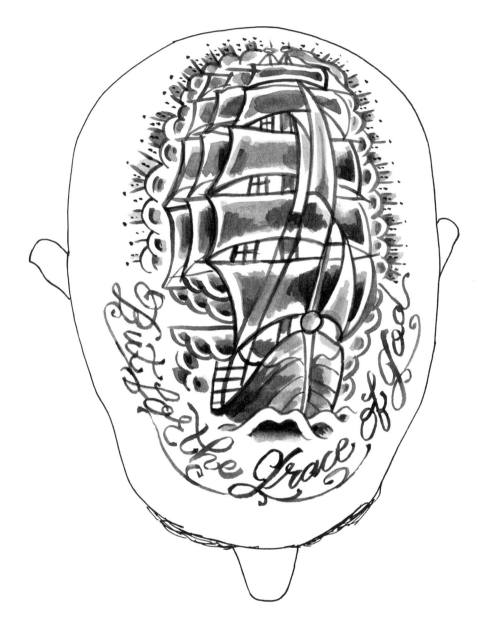

OWNER OF AND CHEF
AT EATWELLNEWYORK
NEW YORK CITY, NEW YORK

CLIFF SHAPIRO

# NICHOLAS PORCELLI

THE SHIP RIDING THE CHOPPY WAVES of THE SEA SYMBOLIZES THE TROUBLES I'VE SURVIVED and THE POSITIVE PLACES I'M GOING—"BUT for THE GRACE OF GOD."

# LAUREN MACELLARO

I WAS NUMBER TWO AT A RESTAURANT IN ASHEVILLE, NORTH CAROLINA, WHERE ON SUNDAYS IT WAS JUST THE LADIES RUNNING THE KITCHEN. ONE of THEM WAS A GIRL I HIRED TO FILL A LINE COOK POSITION— I KNEW WITHIN TEN MINUTES THAT SHE WAS A KEEPER. ON THOSE SUNDAYS, ALL of US MADE IT A TRADITION TO ORDER CHINESE FOOD WHILE WE PREPPED. EACH and EVERY ONE of US WOULD GET OUR OWN QUART of HOT and SOUR SOUP. MAYBE SPICY EGGPLANT and SOME EGG ROLLS TOO, BUT THE HOT and SOUR WAS ALWAYS A MUST.

THE GIRL I'D HIRED EVENTUALLY GOT ANOTHER JOB and HAD TO MOVE. BUT WE VOWED TO COOK TOGETHER AGAIN SOMEDAY, and GOT MATCHING TATTOOS TO SEAL THE DEAL. NOW I'M OPENING UP MY OWN RESTAURANT IN ST. PETERSBURG, FLORIDA, and GUESS WHO I'VE ENLISTED AS MY NUMBER TWO? WE ARE ALL UNIQUE RECIPES of WHO WE COOK WITH OVER THE COURSE of OUR CAREERS.

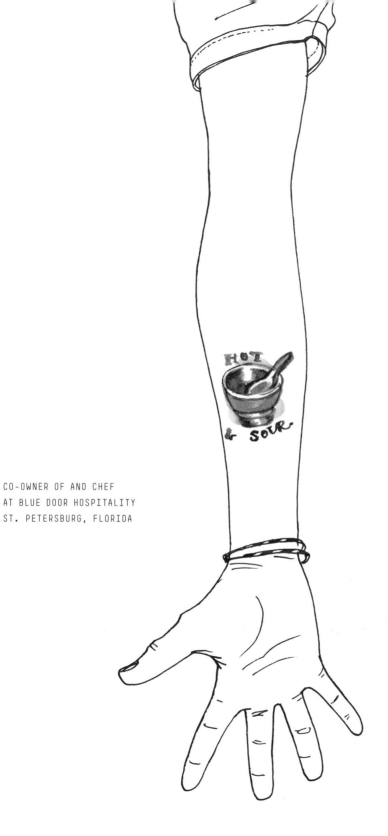

CO-OWNER OF AND CHEF
AT BLUE DOOR HOSPITALITY
ST. PETERSBURG, FLORIDA

## Cake

*Cake*

*Makes two 9-inch round cakes*

2½ CUPS BUTTER
2 CUPS DRY MILK SOLIDS
   (NOT THE FINE POWDER)
2¼ CUPS SUGAR
1 CUP BROWN SUGAR
5 EGGS AT ROOM TEMPERATURE
3¾ CUPS ALL-PURPOSE FLOUR, SIFTED
2½ TABLESPOONS BAKING POWDER, SIFTED
1⅝ TABLESPOON SALT, SIFTED
1⅝ CUP MILK
1¾ TABLESPOON VANILLA EXTRACT, REAL-DEAL KIND

# LAUREN MACELLARO'S BROWN-BUTTER CAKE with KUMQUAT and SEA-SALTED ICE CREAM

Toast the milk solids in melted butter until amber color. Remove from heat; cool to room temperature. Whip the sugars with the browned butter mixture till fluffy. Add eggs one at a time, scraping the bottom to uniformly incorporate. Combine remaining dry ingredients. Add the dry mixture in thirds, alternating with milk and vanilla combined.

Grease the pans generously with butter and lightly sprinkle with flour. Remove any flour that hasn't adhered to the butter. Place pans on a full sheet pan in a 350° F oven. Bake for 30 minutes, rotate 180 degrees, and continue for another 25 minutes or so, until cake tester is clean. (Non-convection time and temperature.)

*Kumquat puree*

4 CUPS WATER
2 CUPS KUMQUATS
1 CUP SUGAR
1 CUP HEAVY CREAM
3 TABLESPOONS BUTTER
1 SPRIG THYME
⅛ TEASPOON XANTHUM GUM

Cook the kumquats, water, sugar, and thyme on medium heat until kumquats soften significantly, approximately 35 minutes. Make sure they are not rapidly boiling to prevent rapid reduction. Remove the sprig of thyme and add the heavy cream; reduce by half. Strain, reserving the liquid.

Transfer to Vitamix and puree until smooth and a vortex forms. Adding a little liquid at a time to achieve this result, you might use it all. Emulsify with butter, and set the emulsion with xanthum gum. Strain through mesh strainer and refrigerate.

*Sea-salt gelato cheat*

Add Maldon sea salt to your favorite vanilla gelato . . . to taste. I like mine salty so I use 1 tablespoon for a quart. When making your own, spin the Maldon during the last five minutes of churning.

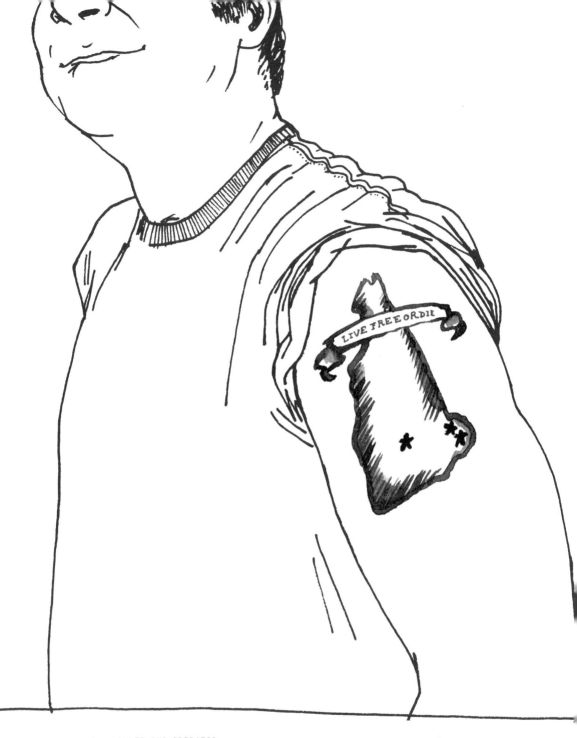

LIVE FREE OR DIE

OWNER AND OPERATOR
AT DOS AMIGOS BURRITOS
NEW HAMPSHIRE AND MASSACHUSETTS

# JOEL HARRIS

MY TATTOO IS AN HOMAGE TO NEW HAMPSHIRE, MY
ADOPTED HOME STATE. IT HAS GIVEN ME THREE
SUCCESSFUL RESTAURANTS and MY WIFE, MY BABY
DAUGHTER, and MY HOME. I LOVE NEW HAMPSHIRE
and ITS ENTREPRENEURIAL SPIRIT. THE STARS ON
THE TATTOO REPRESENT MY THREE RESTAURANT LOCATIONS:
PORTSMOUTH, DOVER, and CONCORD, and of COURSE,
"LIVE FREE OR DIE" IS THE BEST STATE MOTTO IN
THE COUNTRY.

## JOEL HARRIS'S DOS AMIGOS SALSA VERDE

1 POUND TOMATILLOS, HUSKED
1 WHITE ONION, PEELED AND QUARTERED OR WHOLE
4 GARLIC CLOVES
2 JALAPEÑOS
2 TEASPOONS GROUND CUMIN
1 TEASPOON SALT
½ CUP CHOPPED CILANTRO LEAVES
½ LIME, JUICED

On a baking tray, roast tomatillos, onion, garlic, and jalapeños for 12
to 15 minutes. Transfer the roasted vegetables and any juices on the
bottom of the tray to a food processor. Add the cumin, salt, cilantro,
and lime juice and pulse mixture until well combined but still chunky.

# GRACIE LIEBERMAN

I GOT THIS TATTOO ABOUT FIVE YEARS AGO, WHEN
I WAS WORKING AT A BISTRO ON ELIZABETH STREET
SHUCKING OYSTERS. I KNEW I WANTED A TATTOO
of A CALENDAR BECAUSE I WAS INTERESTED IN THE
PASSAGE of TIME and HOW WE MARK IT. I HAD
PLANNED TO GET THE DESIGN ON MY ARM, BUT THE GUY
TOOK ONE LOOK AT MY SCRAWNY BICEP AND WAS
LIKE, "WE CAN EITHER DO THIS AROUND YOUR WAIST,
OR THE FATTEST PART of YOUR LEG. UNLESS YOU
WANT TO TAKE UP BODYBUILDING." SO ON MY THIGH
IT WENT. I GET A LOT of ATTENTION for THIS
TATTOO, SOME COMMENTS MORE WELCOME THAN OTHERS.
EVERY ONCE IN A WHILE FOLKS STOP ME ON THE
STREET, STICK THEIR FACE IN MY BUSINESS, and SAY
STUFF LIKE, "YO, I'M A VIRGO, WHAT DOES THAT
MEAN?!?!" IF SOMEBODY IS REALLY BOTHERING ME, I
TELL THEM THE TATTOO HAS TO DO with CHARTING
MY MENSTRUAL CYCLE, WHICH USUALLY SHUTS THEM
UP. OTHER PEOPLE ASK ME IF IT'S A TREASURE MAP.
I ALWAYS SAY YES.

OWNER OF AND PERSONAL CHEF
AT THE ROYAL RADISH
BROOKLYN, NEW YORK

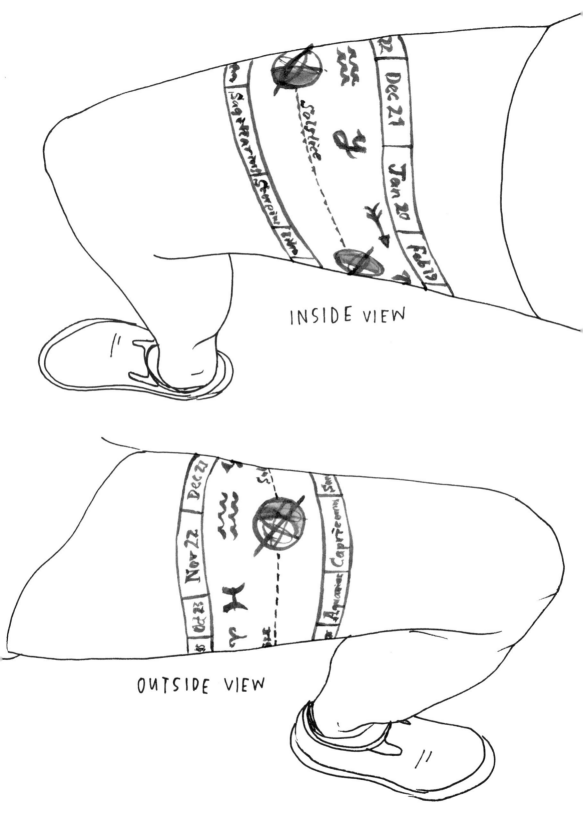

INSIDE VIEW

OUTSIDE VIEW

CHEF
AT ALL SOULS,
CO-FOUNDER OF AND BUTCHER
AT INTENTIONAL SWINE
ASHEVILLE, NORTH CAROLINA

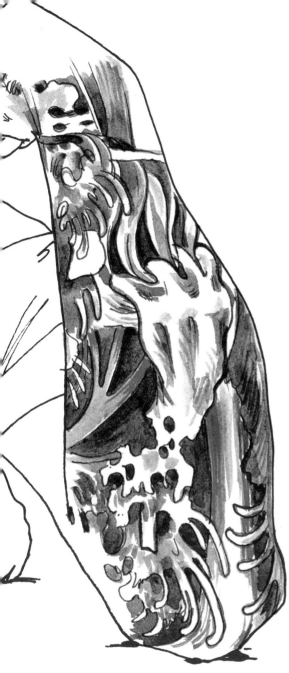

# JEREMIAH TODD DeBRIE

I WAS WORKING AT A VERY HIP RESTAURANT IN BOSTON WHERE WE DEALT with WHOLE PIGS OFTEN, and I WAS THE BUTCHER. I DIDN'T WANT your RUN-of-THE-MILL PIG TATTOO, SO I WENT TO THE GNARLIEST TATTOO ARTIST IN TOWN and TOLD HIM I WANTED A BADASS PIG BEING RIPPED APART BY ZOMBIE HANDS. I THOUGHT I'D BE GETTING A SMALL FOREARM TATTOO, BUT WHEN THE ARTIST PULLED OUT THIS GRUESOME SLEEVE DESIGN ON A HUGE PIECE of PARCHMENT, I SAID, "FUCK IT. A SLEEVE IT IS."

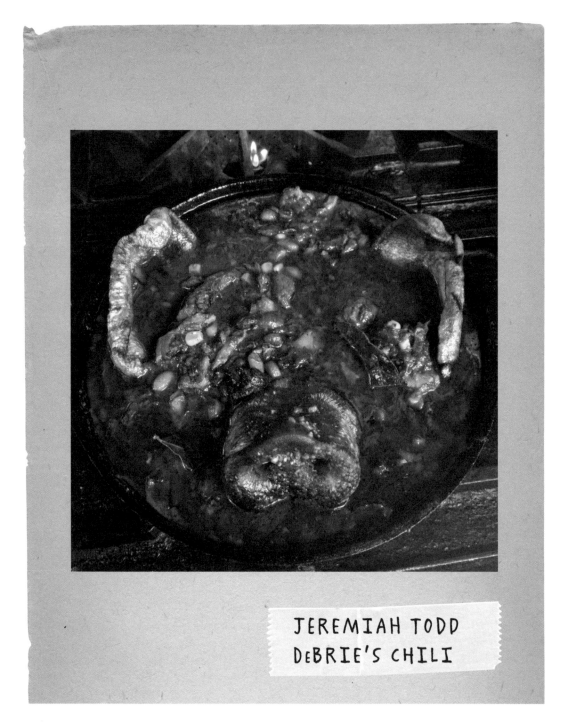

JEREMIAH TODD
DeBRIE'S CHILI

Slaughter 1 PIG, 300-400 POUNDS (scald, scrape, eviscerate, butcher), reserve bones for stock, fat for lard. Set aside ears, snout, tail. Set aside 5 pounds ground pork. Set aside all four shanks and the neck.

2 CUPS EACH CARROT, CELERY, ONION, BRUNOISE-CUT
1 CUP CHOPPED GARLIC
SACHET OF FRESH HERBS: THYME, ROSEMARY, PARSLEY, BAY LEAVES
DRIED MUSHROOMS, MAITAKE OR PORCINI
5 SMOKED FATALI PEPPERS OR 15 SMOKED JALAPEÑOS
¼ CUP CHILI POWDER
10 TO 15 FRESH TOMATOES
1 TALL BOY
1 GALLON RICH PORK STOCK
3 POUNDS PARCOOKED OR FRESH BEANS (TURTLE BEANS, YELLOW-EYED PEAS, NAVY BEANS, ETC.)
2 CUPS PURÉED RAW PORK OR CHICKEN LIVER
1 CUP PEANUT BUTTER
¼ CUP FISH SAUCE

*Do ahead*

Preheat oven to 400° F. Season with salt and pepper all four shanks and the neck, and roast along with tomatoes until golden brown. Turn the oven down to 275° F.

Season with salt and pepper the ears, snout, and tail. Cover with melted lard and confit in the oven 2 to 3 hours.

Bring stock to a boil and leave on a low simmer.

*For the chili*

Start with a large heavy-bottomed pot and let it get pretty hot, then add ground pork, salt, and pepper. Cook, stirring frequently, until cooked through. Add vegetables, dried mushrooms, smoked chilis, and chili powder. Cook, stirring frequently, until just tender.

Pour in your beer and stir to free up anything sticking to the bottom of the pan. Add in your roasted shanks, neck, and tomatoes, mixing everything together. From your pot of hot stock, add enough to cover the meat and bring to a boil. Add the parcooked beans and turn down to a simmer. Continue to cook, stir, and add stock until the meat is falling off the bones. Remove inedible bones.

When you've reached your desired consistency and doneness, pour in puréed liver, stirring well. Once incorporated, add peanut butter, stirring well. Once incorporated, stir in fish sauce. Continue to cook 5 to 10 more minutes and feel free to adjust seasonings. Bragg's amino acid is a good alternative to more salt and has a unique and delicious flavor.

Garnish your chili with confit of tail, ears, and snout. Enjoy with good bread and lots of fresh scallions.

# JOHN GORHAM

WHEN I FIRST BECAME A CHEF IN PORTLAND
A FEW of THE COOKS AT THE RESTAURANT
WHERE I STARTED SAID TO ME, "YOU DON'T
FUCK AROUND. YOU JUST CAME IN
and TOOK OVER THE KITCHEN LIKE A BULL."
BUT THAT'S WHAT I DO—I CHARGE. SO
I GOT A BULL ON MY FOREARM. WHEN WE
OPENED MY FIRST PLACE IN 2007, WE
NAMED IT AFTER MY BULL TATTOO. TORO
BRAVO, THE BRAVE BULL.

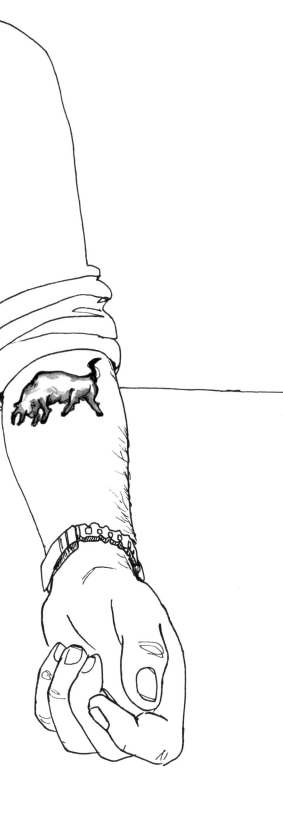

OWNER OF AND CHEF
AT TORO BRAVO, TASTY N SONS,
TASTY N ALDER, MEDITERRANEAN
EXPLORATION COMPANY,
AND PLAZA DEL TORO
PORTLAND, OREGON

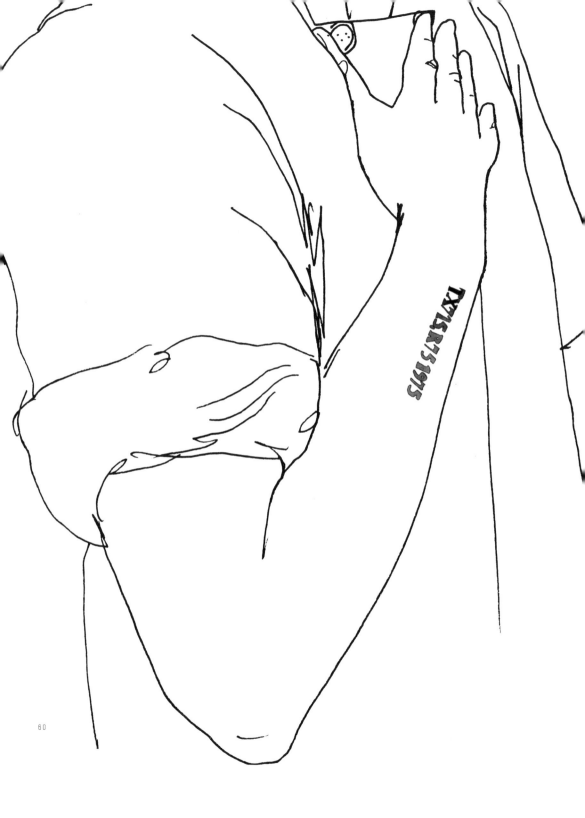

# KATE ROMANE

MY TATTOO IS THE LIBRARY OF CONGRESS CALL NUMBER for JOY of COOKING BY IRMA S. ROMBAUER. IT WAS THE FIRST COOKBOOK I EVER OWNED. I LOVE TO REMEMBER MY ROOTS AS A CHEF and MAKE HONEST FOOD, and THIS SMALL CODED NUMBER of JOY of COOKING ALWAYS BRINGS ME BACK TO MY ROOTS.

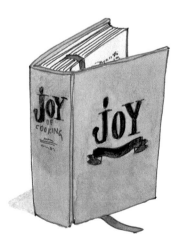

OWNER OF AND CHEF
AT E2 RESTAURANT
AND KATE ROMANE PRODUCTIONS
PITTSBURGH, PENNSYLVANIA

# TRAVIS MILTON

I DECIDED LONG AGO THAT I WOULD DEDICATE MY LIFE
and CULINARY WORK TO HELP PRESERVE and FURTHER
THE FOODWAYS of APPALACHIA, WHERE I AM FROM.
I GREW UP IN RURAL SOUTHWESTERN VIRGINIA,
and WAS BLESSED TO KNOW THE GREAT-GRANDPARENTS
ON BOTH SIDES of MY FAMILY, and EVEN MY GREAT-
GREAT-GRANDMOTHER ON MY FATHER'S SIDE. MY SLEEVE
IS A REPRESENTATION of WHAT I GREW UP with IN
RUSSELL and WISE COUNTIES, VIRGINIA. IT REPRESENTS
MY HOPES and VISION for A SUSTAINABLE FUTURE
THERE. SO MANY BEAUTIFUL HEIRLOOM VEGETABLES ARE
RISING OUT of THE ASHES of WHAT WAS ONCE
COAL COUNTRY. MY SLEEVE INCLUDES CHEROKEE LONG
GREASY BEANS, ONE of HUNDREDS of HEIRLOOM
BEANS FROM APPALACHIA. THIS PARTICULAR VARIETY
HAS BEEN GROWN BY MY FAMILY for AT LEAST
SEVEN GENERATIONS, and I GROW THEM STILL TODAY
FROM THOSE VERY SEEDS THAT HAVE BEEN PASSED
DOWN THROUGHOUT GENERATIONS of MY FAMILY.

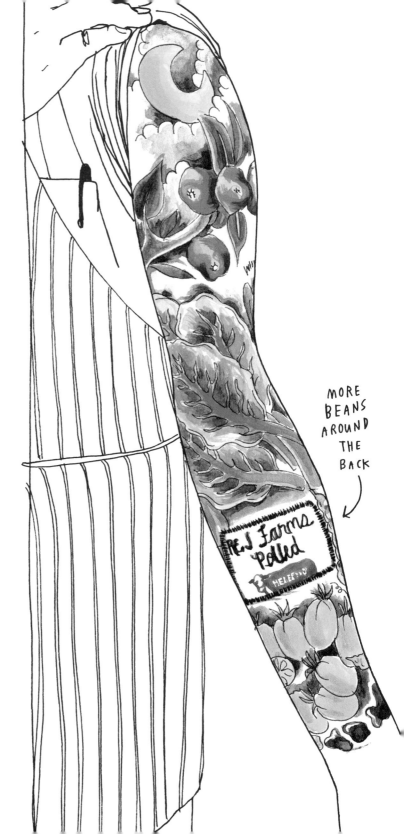

MORE
BEANS
AROUND
THE
BACK

RED Farms
Polled

MELEFFSO

CO-OWNER OF AND CHEF
AT SHOVEL AND PICK
RICHMOND, VIRGINIA

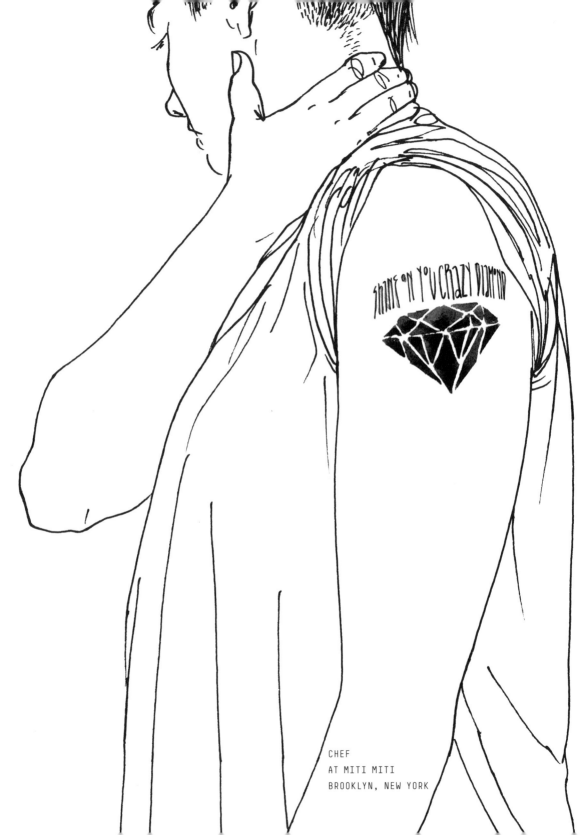

SHINE ON YOU CRAZY DIAMOND

CHEF
AT MITI MITI
BROOKLYN, NEW YORK

# ALISA FRALOVA

I CAME TO THE UNITED STATES WHEN I WAS TWENTY *with* SIX HUNDRED DOLLARS *and* NO IDEA WHAT TO DO. I WAS STUDYING ENGINEERING *and* ECONOMICS, BUT DROPPED OUT *of* COLLEGE A YEAR BEFORE I WOULD HAVE GOTTEN MY DEGREE *and* MOVED TO NEW YORK INSTEAD. MY FATHER, WHO HAD BEEN A LIEUTENANT IN THE SOVIET ARMY WHEN HE WAS AROUND MY AGE, WAS VERY UPSET WHEN HE FOUND OUT I WASN'T COMING BACK. HE DIDN'T TALK TO ME *for* ALMOST A YEAR. ALL MY LIFE, HE WOULD TELL ME HOW I'D NEVER ACHIEVED ANYTHING *and* I'D ALWAYS DROP OUT IN THE MIDDLE *of* WHATEVER I WAS TRYING TO DO. WHEN WE STARTED TALKING AGAIN, HE HAD LATE-STAGE CANCER.

AFTER MY FATHER PASSED, I MADE A PROMISE TO MYSELF THAT I'D START SOMETHING NEW *and* NOT BAIL OUT. THE YEAR AFTER THAT I GOT MY FIRST PREP COOK JOB, *and* THREE YEARS LATER I WAS AN EXECUTIVE CHEF. I HAD GOTTEN A BUNCH *of* RANDOM TATTOOS BY THEN, BUT I REALLY WANTED SOMETHING THAT WOULD REMIND ME *of* MY FATHER EVERY DAY WHEN I LOOKED IN THE MIRROR, TO REMIND ME HOW I GOT TO WHERE I WAS NOW. HE WAS A HUGE PINK FLOYD FAN SO I DIDN'T EVEN THINK TWICE ABOUT WHAT TO GET. THE NAME OF THE SONG THAT ALWAYS DESCRIBED HIM BEST: "SHINE ON YOU CRAZY DIAMOND."

# DONNIE MASTERTON

IN 2008, I WAS ABOUT TO OPEN MY VERY OWN RESTAURANT. I WAS WORKING ON THE GRAPHIC DESIGN WITH AN ARTIST FRIEND OF MINE, and WE WERE TRYING TO COME UP with AN IMAGE THAT PEOPLE WOULD RECOGNIZE and ASSOCIATE IMMEDIATELY with MY RESTAURANT. MY FRIEND KEPT COMING BACK TO ME with DIFFERENT IMAGES: A KNIFE, A WHISK, A RADISH, A FISH. BUT NONE of THEM FELT QUITE RIGHT.

ONE MORNING I AWOKE THINKING ABOUT BIRDS. ACTUALLY, JUST ONE BIRD IN PARTICULAR. MY YOUNGEST DAUGHTER HAD DRAWN ME A FAMILY of BIRDS A FEW YEARS AGO WHEN SHE WAS ABOUT SIX YEARS OLD. WHEN SHE CUT THEM OUT and GAVE THEM TO ME AS A GIFT, I STUCK THEM TO THE DOOR of OUR FRIDGE. OVER TIME, BIRD AFTER BIRD FELL OFF THE DOOR UNTIL ONLY ONE WAS LEFT. THAT'S THE BIRD I WAS THINKING ABOUT. IT TURNS OUT THE IMAGE HAD BEEN IN FRONT of ME THE WHOLE TIME. THIS BIRD REPRESENTED EVERYTHING I WAS LOOKING for,

EMBODYING A CHILDLIKE HONESTY
THAT WAS WHIMSICAL and SIMPLE.
IN 2011, I GOT THESE THREE BIRDS
TATTOOED ON ME for THE THREE-YEAR
ANNIVERSARY of MY RESTAURANT,
BUT IT ALSO REPRESENTS ME and
MY TWO DAUGHTERS, GRACIELLA
and SOPHIA.

CO-OWNER AND CHEF
AT THE RESTAURANT
SAN MIGUEL DE ALLENDE, MEXICO

# DONNIE MASTERTON'S GRILLED PIRI PIRI CHICKEN with SLAW and FLAKY FLATBREAD

*Piri Piri Chicken*
¼ CUP FRESH CILANTRO, CHOPPED
1 2-INCH PIECE FRESH GINGER, PEELED AND CHOPPED
1 LARGE SHALLOT, PEELED AND CHOPPED
5 GARLIC CLOVES, PEELED AND CHOPPED
6 RED FRESNO CHILES, STEMMED AND ROUGHLY CHOPPED
4 RED THAI CHILES, STEMMED AND ROUGHLY CHOPPED
¼ CUP RED WINE VINEGAR
¼ CUP LIME JUICE, FRESHLY SQUEEZED
½ CUP OLIVE OIL
2 TEASPOONS KOSHER SALT
1½ POUNDS BONELESS, SKINLESS CHICKEN THIGHS, CUT INTO 1½-INCH CHUNKS
BAMBOO SKEWERS, SOAKED IN WATER FOR AT LEAST 1 HOUR
OLIVE OIL FOR GRILLING

*Cabbage and cucumber slaw*
¼ SMALL HEAD GREEN CABBAGE, VERY THINLY SLICED (ABOUT 2½ CUPS)
½ ENGLISH CUCUMBER, HALVED LENGTHWISE AND THINLY SLICED ON AN ANGLE (ABOUT ¾ CUP)
¼ WHITE ONION, VERY THINLY SLICED (ABOUT ¼ CUP)
¼ CUP LOOSELY PACKED FRESH MINT LEAVES, THINLY SLICED
2 TABLESPOONS OLIVE OIL
2 TABLESPOONS LIME JUICE, FRESHLY SQUEEZED
1 TABLESPOON FINELY GRATED LIME ZEST
KOSHER SALT AND PEPPER TO TASTE

Make the piri piri chicken: In a food processor, combine the cilantro, ginger, shallot, chiles, garlic, vinegar, lime juice, and salt. Pulse until finely minced. With the machine running, add 1/2 cup of olive oil and pulse until smooth. Set aside.

In a large bowl, toss the chicken with 2/3 cup of the piri piri mixture to coat. Cover and chill for at least 4 hours or preferably overnight. Cover and chill the remaining piri piri sauce.

Prepare the cabbage and cucumber slaw about 30 minutes before grilling the chicken: In a large mixing bowl, toss the cabbage, cucumber, onion, mint, olive oil, lime juice, and zest. Season to taste with kosher salt.

Prepare a grill for medium-hot heat or place a grill pan over medium-high heat. Thread 4 to 5 pieces of chicken onto each skewer.

Using a pastry brush, coat the grill with the remaining tablespoon of oil.

Grill the chicken, turning and basting often with the remaining 1/3 cup of sauce, until the chicken is cooked through and charred in spots, 12 to 15 minutes.

To serve, divide the chicken skewers, slaw, and flatbreads among 4 plates. Serve the remaining piri piri sauce alongside for dipping.

*Flaky flatbread*

*Makes 10*

1 TEASPOON KOSHER SALT

3 CUPS ALL-PURPOSE FLOUR, PLUS MORE FOR SURFACE

6 TABLESPOONS UNSALTED BUTTER, MELTED, PLUS MORE
  ROOM TEMPERATURE, FOR BRUSHING (ABOUT 10 TABLESPOONS TOTAL)

FLAKY SEA SALT (SUCH AS MALDON)

OLIVE OIL (FOR PARCHMENT)

Whisk kosher salt and 3 cups flour in a large bowl. Drizzle in melted butter; mix well. Gradually mix in 3/4 cup water. Knead on a lightly floured surface until dough is shiny and very soft, about 5 minutes. Wrap in plastic; let rest in a warm spot at least 4 hours.

Divide dough into 10 pieces and, using your palm, roll into balls. Place balls on a baking sheet, cover with plastic wrap, and let rest 15 minutes.

Working with 1 piece at a time, roll out balls on an unfloured surface with a rolling pin into very thin rounds or ovals about 9 inches across. (If dough bounces back, cover with plastic and let rest a few minutes.)

Brush tops of rounds with room-temperature butter and sprinkle with sea salt. Roll up each round to create a long thin rope, then wind each rope around itself to create a tight coil.

Working with one coil at a time, roll out on an unfloured surface to 10-inch rounds no more than 1/8-inch thick. An unfloured surface provides some traction, so it's easy to roll the dough very thin. Stack as you go, separating with sheets of parchment brushed with oil.

Heat a large cast-iron griddle or skillet over medium-high heat. Working one at a time, brush both sides of a dough round with room-temperature butter and cook until lightly blistered and cooked through, about 2 minutes per side. Transfer bread to a wire rack and sprinkle with sea salt.

*Do ahead*

Coils can be rolled out one month ahead; wrap tightly and freeze. Cook from frozen (add 1–2 minutes to cooking time).

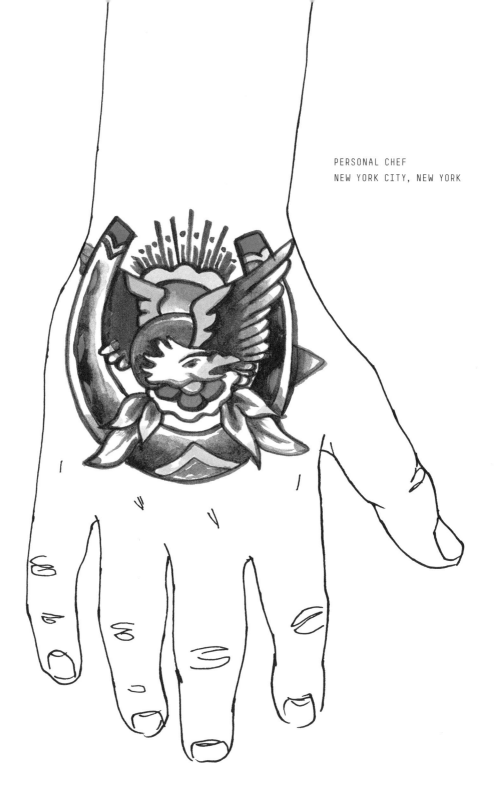

# MATT MARCHESE

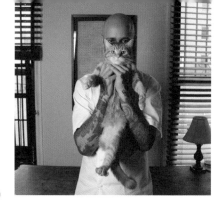

I GREW UP ON HORSESHOE DRIVE IN DERRY, NEW HAMPSHIRE, and WANTED TO PAY HOMAGE TO MY CHILDHOOD MEMORIES. AND WHO DOESN'T LIKE EAGLES? GETTING THE TATTOO WASN'T TOO PAINFUL, SINCE I POPPED A PERCOCET and POUNDED SOME BEERS BEFOREHAND. I WAS A BIT APPREHENSIVE ABOUT HAVING SUCH A LARGE TATTOO ON MY HAND, BECAUSE I WORK for HIGH-END CLIENTS with POLISHED LIFESTYLES. BUT IT FELT IMPORTANT TO HONOR MY PAST BY MARKING MYSELF SO OBVIOUSLY. IT'S NOT LIKE IT WOULD CHANGE THE TASTE of THE FOOD I MADE. IN THE END, MY CLIENTS NEVER EVEN MENTIONED IT.

## MATT MARCHESE'S CHOCOLATE CREAM with TOASTED SPICES

1 KILOGRAM CREAM
360 GRAMS DARK CHOCOLATE (70 PERCENT)
2 GRAMS VANILLA
½ TEASPOON SALT
20 GRAMS COCOA NIBS
2 GRAMS CORIANDER
1 GRAM FENNEL SEED
1 GRAM CUMIN SEED

In a heavy-bottomed pot, heat the cream to just under a boil. Place the chocolate, salt, and vanilla in a bowl and pour the hot cream over the chocolate. Let stand for 5 minutes, then mix until smooth. Refrigerate overnight to set.

Once set, whip the mixture until slightly thickened. Be careful to not over-whip, as it will result in a sandy texture.

Place the coriander, fennel, and cumin in a skillet. Over medium flame toast the spices well. Once toasted, transfer to a mortar and use the pestle to slightly grind the spices. Add to a small bowl with cocoa nibs.

To serve, place a large quenelle of the chocolate cream on a plate and top with a generous pinch of the spices and nibs.

# JAMIE BISSONNETTE

I WAS JUST A YOUNG LINE COOK WHEN
I GOT THIS TATTOO, BUT I KNEW I WANTED
TO BE A CHEF. I HAD LEARNED THAT EVERY
ARTIST, WHETHER PAINTER OR WRITER OR ONE
WHO WORKS *with* FOOD, HAS A SINISTER
SIDE. THAT'S WHAT THIS TATTOO REPRESENTS
TO ME, MY DEVILISH AMBITION.

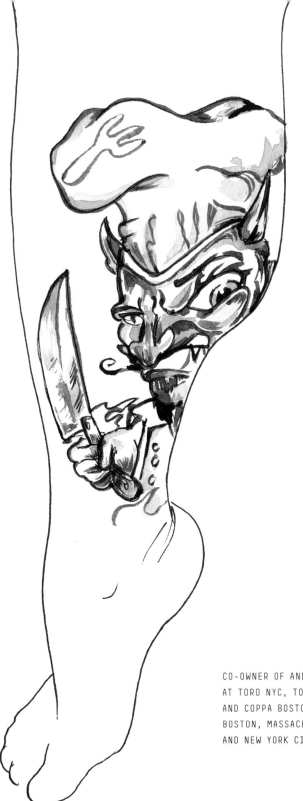

CO-OWNER OF AND CHEF
AT TORO NYC, TORO BOSTON,
AND COPPA BOSTON
BOSTON, MASSACHUSETTS,
AND NEW YORK CITY, NEW YORK

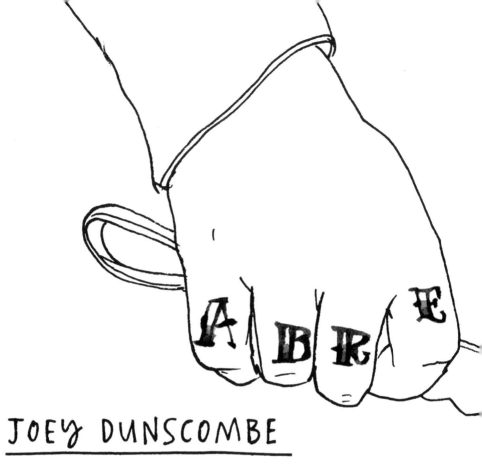

# JOEY DUNSCOMBE

I GOT A TATTOO of MY WIFE'S INITIAL, J, IN PLACE
of A WEDDING RING WHEN I WAS MARRIED IN 2001.
WE WERE TOGETHER for ELEVEN YEARS. AFTER WE GOT
DIVORCED, I WANTED TO COVER IT UP with SOMETHING.
NEW MEMORIES, RIGHT? SO AFTER A FEW YEARS of
PONDERING, A FRIEND CAME UP with "ABRE OJOS," WHICH
MEANS "OPEN EYES" IN SPANISH. MY RELATIONSHIP
with MY EX-WIFE DEFINITELY OPENED MY EYES IN A
BUNCH of WAYS. HAD TO SLIDE THE "O" and "S" ONTO
THE PINKIE FINGER, BUT IT FEELS SO RIGHT!

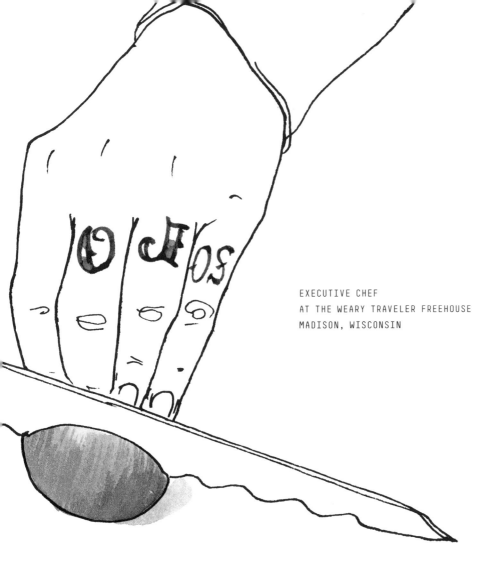

EXECUTIVE CHEF
AT THE WEARY TRAVELER FREEHOUSE
MADISON, WISCONSIN

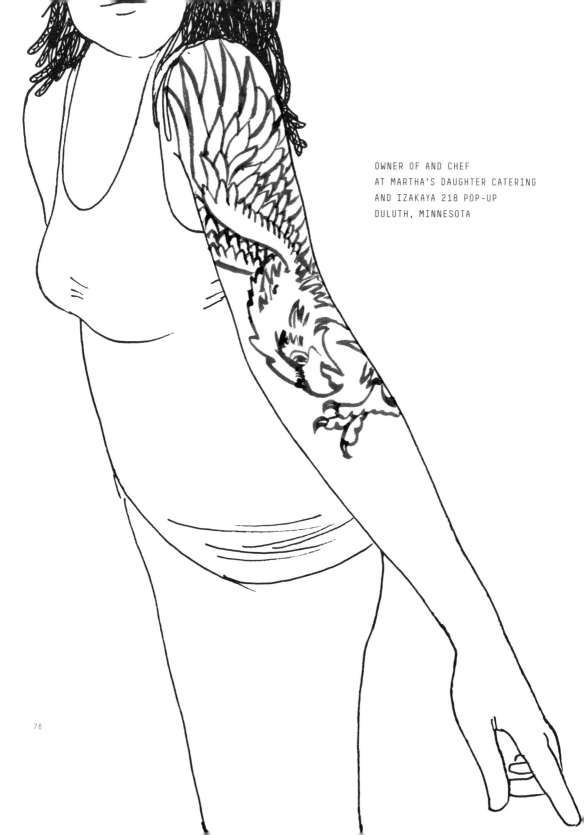

OWNER OF AND CHEF
AT MARTHA'S DAUGHTER CATERING
AND IZAKAYA 218 POP-UP
DULUTH, MINNESOTA

# NYANYIKA BANDA

I SPENT A COUPLE SUMMERS WORKING AS A
SEASONAL CHEF AT A RESORT IN THE WILDS of
NORTHERN MINNESOTA. ON A TYPICAL DAY
I WAS RESPONSIBLE for COOKING BREAKFAST,
LUNCH, and DINNER for
STAFF and GUESTS AS
THEY PREPARED TO GO OUT OR
COME BACK FROM CANOE
TRIPS. IN THE AFTERNOONS
I'D GET A FEW HOURS OFF.
SOME DAYS I WOULD GO for

HIKES, OTHER DAYS I WOULD TAKE OUT A CANOE
and SEE HOW CLOSE TO THE CANADIAN BORDER
I COULD PADDLE. PICTURESQUE WAS AN UNDER-
STATEMENT: with MINIMAL HUMAN IMPACT
DUE TO PRESERVATION, THIS WAS A PLACE of
NATURAL BEAUTY and WONDERMENT. ON
ONE of MY PADDLE DAYS I WAS ABOUT HALF
A MILE FROM MY DOCK WHEN I NOTICED A
BIRD ABOVE ME. IT WOULD FLAP ITS WINGS
ONCE OR TWICE THEN SOAR GRACEFULLY
IN CIRCLES ABOVE MY HEAD. IT SWOOPED CLOSE
ENOUGH for ME TO REALIZE IT WAS AN
AMERICAN BALD EAGLE. ...CONTINUED ON NEXT PAGE

...CONTINUED FROM LAST PAGE THIS WAS MY FIRST TIME SEEING ONE and I WAS CRIPPLED BY ITS MAJESTIC EASE. I STOPPED PADDLING and WATCHED IT LAND BACK AT ITS NEST. WITHIN A MINUTE THE EAGLE WAS BACK IN THE AIR, THIS TIME with THREE BABY EAGLETS IN TOW. I WATCHED THE MOTHER and CHILDREN for MY ENTIRE BREAK, JUST SITTING IN MY CANOE.

SIX YEARS LATER, AFTER LIVING and WORKING IN NEW YORK CITY, I DECIDED TO FINALLY GET MY EAGLE TATTOO. I HAD JUST FINISHED ANOTHER SEASONAL JOB UPSTATE and HAD ENOUGH CASH for THE OUTLINE. THE CHEF'S KNIFE IN THE BIRD'S TALON WAS A NEW IDEA THAT CAME TO ME THE NIGHT BEFORE MY APPOINTMENT. I WANTED SOMETHING TO MARK THE FIFTEEN YEARS of CHOPPING, BLEEDING, CRYING, and LAUGHING THAT I HAD SPENT IN KITCHENS. IT IS MY WAY of VALIDATING MY EXISTENCE IN THE CULINARY WORLD. NO MATTER WHAT MY FUTURE BRINGS, MY CHEF'S KNIFE WILL ALWAYS BE AN EXTENSION of MY OWN HAND.

# MONICA LO

I'M ALWAYS TINKERING IN THE TEST KITCHEN,
TAKING PHOTOS, and MAKING EDIBLES. I
GREW UP COOKING TAIWANESE and SICHUAN
CLASSICS with MY PARENTS BUT I'M
NOT A CLASSICALLY TRAINED CHEF.

I'M IN THE PROCESS of COLLECTING HERB
and SEASONING TATTOOS for EVERY MAJOR
MILESTONE of MY LIFE. I HAVE ROSEMARY and
THYME for THE EIGHT YEARS I SPENT HUSTLING
IN NYC. I HAVE CORIANDER BLOSSOMS ON MY
BACK for THE NEW LIFE I CREATED for MYSELF

IN SAN FRANCISCO. JUST
RECENTLY, I GOT LINGON-
BERRIES TO COMMEMORATE
AN EPIC FOOD TOUR of
OSLO and COPENHAGEN,
WHERE I HAD THE ONCE-IN-
A-LIFETIME OPPORTUNITY
TO DINE AT NOMA BEFORE

THEY CLOSED for THEIR NEW ADVENTURE.
HOPEFULLY BY THE TIME I DIE, I WILL BE
WELL-SEASONED.

CREATIVE DIRECTOR
AT NOMIKU AND CANNABIS COOK AT SOUS WEED
SAN FRANCISCO, CALIFORNIA

MONICA LO'S UNI
CHAWANMUSHI

*Chawanmushi*
2 TEASPOONS INSTANT DASHI POWDER
2 CUPS WARM WATER
3 LARGE EGGS

*Toppings*
4 PIECES FRESH SEA URCHIN (UNI)
DULSE FLAKES
1 SMALL SUMMER TRUFFLE, SHAVED
CHERVIL LEAVES
FINISHING SALT, LIKE OMNIVORE SALT

Set up a sous vide water bath to 80° C (176° F).

In a medium-sized bowl, whisk dashi powder into the warm water until it is dissolved. Let the dashi broth settle.

In a large bowl, slowly and gently whisk eggs with chopsticks until blended. Do not incorporate too much air, and avoid bubbles. Gently stir the dashi broth into the eggs with chopsticks.

In four 8-ounce Mason jars, slowly pour in chawanmushi base, careful not to create any air bubbles. Seal by securing lid tightly and place into water bath with tongs. Sous vide for an hour. After an hour, gently remove from water bath with tongs.

Top with dulse flakes, a piece of uni, chervil leaves, shaved truffles, and a pinch of finishing salt. Enjoy!

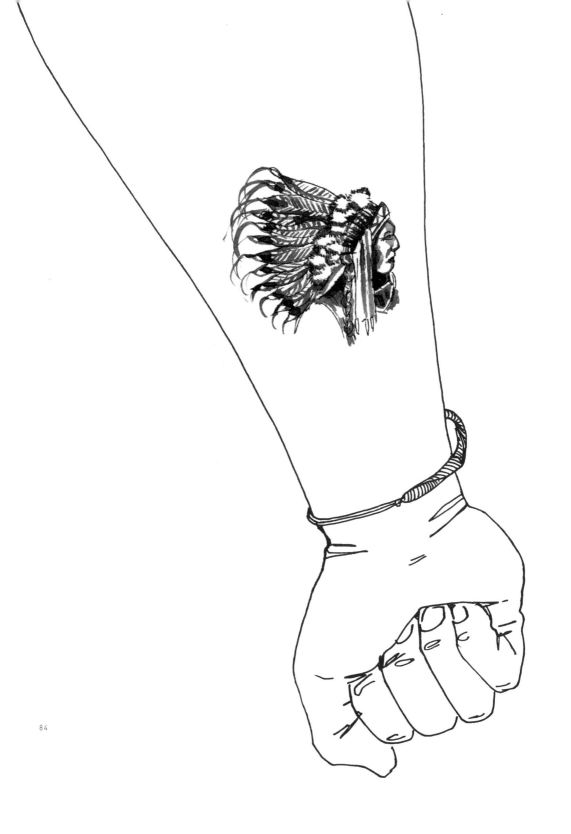

# SAM TALBOT

BEFORE MY GRANDFATHER'S BEST FRIEND DIED
BY HIS SIDE DURING WORLD WAR I,
HE GAVE MY GRANDFATHER A RING HE WORE
with THIS CHIEF ON IT. MY GRANDFATHER
WORE IT HIS WHOLE LIFE, THEN GAVE IT TO
ME. THIS TATTOO COMMEMORATES MY
BELOVED GRANDFATHER and IS MY WAY of
REMEMBERING THE SACRIFICES HE MADE
FIGHTING for THIS COUNTRY.

OWNER OF AND CHEF
AT PIG + POET
CAMDEN, MAINE

# MICHELLE PUSATERI

I WAS ABOUT SIX MONTHS SOBER WHEN I GOT THIS TATTOO, and FEELING INCREDIBLE: CLEAR-MINDED, FOCUSED, NO LONGER ANXIOUSLY WONDERING WHEN THAT NEXT DRINK WAS GOING TO COME. A BURDEN HAD BEEN LIFTED FROM MY SHOULDERS. I FOUND A NEW GROUP of FRIENDS and WAS REGULARLY GOING TO MEETINGS.

I ALREADY HAD A BANNER TATTOO THAT READ "BAKE OR DIE," and I DECIDED MY NEW LIFESTYLE CALLED for ANOTHER ONE. "SWEET N' SOBER" SEEMED TO FIT, BUT I WANTED TO WAIT JUST A BIT LONGER TO MAKE SURE of MY COMMITMENT. FOUR MONTHS LATER, I WAS BACK UNDER THE GUN. THAT WAS ALMOST TEN YEARS AGO.

THERE ARE SO MANY THINGS I WOULDN'T HAVE ACCOMPLISHED WITHOUT BEING SOBER. MY MARRIAGE TO THE PERFECT PARTNER and MY BUSINESS. LIFE HAS A FUNNY WAY of TRYING TO TEACH US LESSONS and GIVING US THE BEST DIRECTION TO GROW and PROSPER. ALL WE HAVE TO DO IS LISTEN, IMPLEMENT, and CREATE.

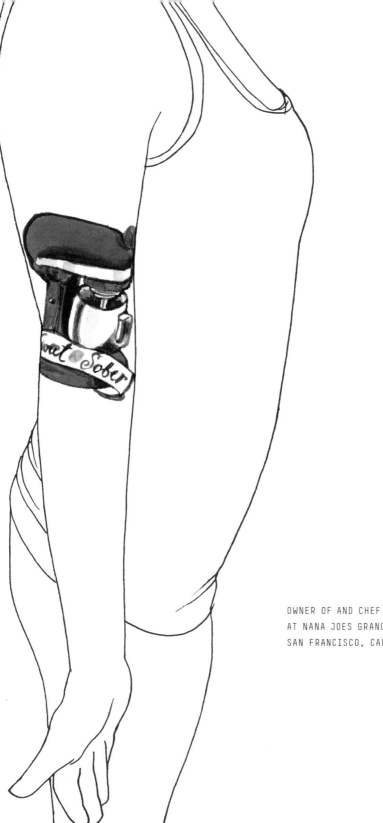

OWNER OF AND CHEF
AT NANA JOES GRANOLA
SAN FRANCISCO, CALIFORNIA

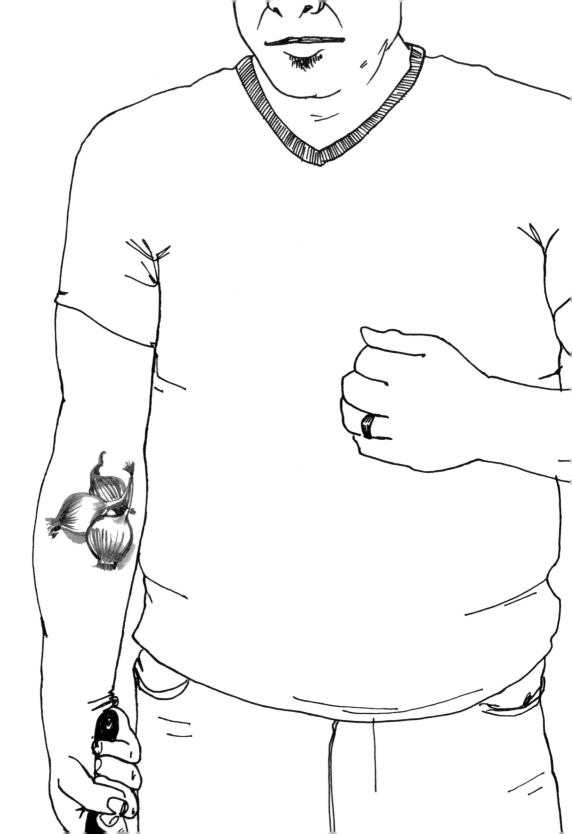

# RIC ORLANDO

I WAS YEARNING *for* A NEW TATTOO. SINCE I WASN'T A KID, *and* WASN'T DESPERATE TO COVER MY BODY IN SKULLS, SPIDERS, OR REGRETTABLE QUOTES, I CHOSE ONIONS BECAUSE THEY ARE THE FOUNDATION *for* JUST ABOUT EVERY CULTURE'S CUISINE. BECAUSE THEY LOOK, *and* ARE, SWEET. I AM PLANNING A NEW TATTOO *for* MY LEFT FOREARM THAT WILL REPRESENT SOMETHING BITTER, BECAUSE, YES, AS CORNY AS IT SOUNDS, LIFE IS INDEED BITTERSWEET. I'M THINKING DANDELIONS OR HORSERADISH.

OWNER OF AND CHEF
AT NEW WORLD HOME COOKING CO.
AND CHEF AT NEW WORLD BISTRO BAR
SAUGERTIES AND ALBANY, NEW YORK

# RIC ORLANDO'S BALSAMIC ROASTED BRUSSELS SPROUTS

Roasted, caramelized, luscious!

Brussels sprouts are one of those kitchen items, like anchovies, fish sauce, and cilantro, that conjure strong feelings on both sides of the aisle. When I was growing up in the '60s, I hated them. We didn't have them often, but like lima beans, when we saw them on our nightly blue plate, they sent waves of dread through the souls of my little sister and me. They were always cooked from frozen until soft and mushy, buttered, salted, and that's it. I am now enlightened! Properly cooked brussels sprouts are an autumn treat. I have taught my kids to get excited about them, and when purchased from a farm stand on a stalk, they are often the star of the meal!

Remember that strong and bitter green vegetables can handle more salt than delicate veggies. This recipe really showcases that.

Some sprouts are wound tighter than others, so the roasting time my vary depending upon the particular batch of sprouts you are cooking. Make sure they are lightly browned, but not black, or you will have bitter sprouts.

Because of the vinegar, this dish pairs well with red meats, venison, beef, and lamb. It is also good served family-style with hearty salmon preparations.

*Serves 4*

```
1 POUND MEDIUM BRUSSELS SPROUTS
2 TO 3 TABLESPOONS EXTRA-VIRGIN OLIVE OIL
4 CLOVES GARLIC, UNPEELED
2 MEDIUM SHALLOTS, CUT IN HALF
6 TABLESPOONS GOOD-QUALITY BALSAMIC VINEGAR
2 SPRIGS ROSEMARY
SALT AND PEPPER TO TASTE
```

Preheat oven to 350° F.

Prepare brussels sprouts by trimming off any dry or loose leaves. Cut off brown end of the stem to expose the white core. Cut an X into the bottom of the core of the stem, about 2 or 3 millimeters deep.

In a mixing bowl, toss all ingredients to coat well. Let marinate at least 15 minutes or up to an hour.

Put everything in a roasting pan and loosely cover with parchment paper or foil. Bake about 30 minutes, then check the sprouts. They will begin to soften and become golden. Poke a big one with a skewer or toothpick. It should be tender. If they need a little more time, let it happen. When they are just tender, remove the covering and allow to cook 10 more minutes until lightly browned. They should be very tender when done.

Serve them right in the roasting dish and make sure everyone gets a piece of shallot and a clove of garlic.

# DANIEL
# FRANCIS
# TOWER

I REALIZED THROUGHOUT MY CAREER AS A CHEF
THAT MY LOVE *for* THE SWINE HAD GROWN.
I KNEW THE HOMAGE NEEDED TO BE FRONT
*and* CENTER. PLUS, SOME *of* MY FAVORITE
PREPARATIONS COME FROM THE HEAD.
GUANCIALE, FROMAGE DE TÊTE, *and*
TONGUE CONFIT, TO NAME JUST A FEW.
AS CHEFS, WE MUST HONOR, RESPECT,
*and* UTILIZE EVERY PART WE CAN.
ALL HAIL THE SWINE.

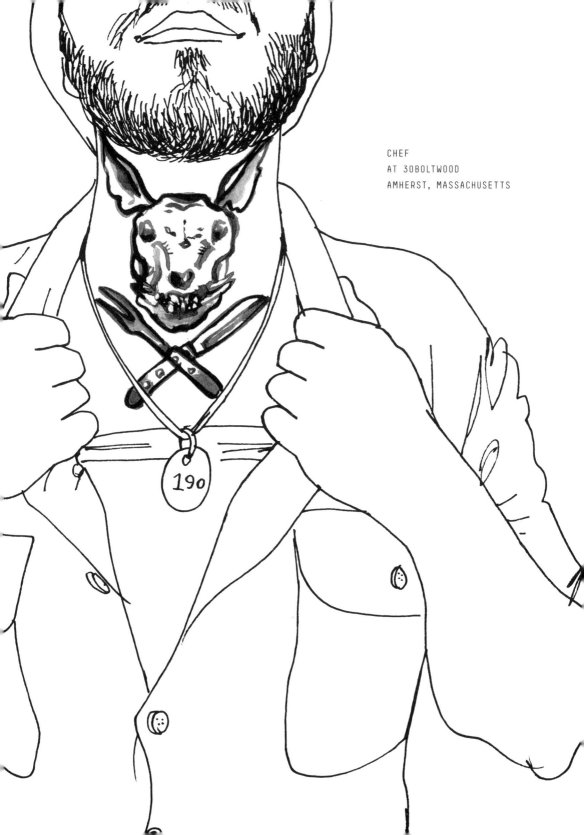

CHEF
AT 30BOLTWOOD
AMHERST, MASSACHUSETTS

# DANIEL FRANCIS TOWER'S PORK HEAD RILLETTE

1 PIG HEAD
½ BUNCH CELERY
2 LARGE CARROTS
2 LARGE WHITE ONIONS
1 HEAD GARLIC
1 BUNCH THYME
1 BUNCH FLAT LEAF PARSLEY, STEM ONLY; SET LEAF ASIDE
3 FRESH BAY LEAVES
1 TABLESPOON PEPPERCORNS
½ CUP WATER AND 3 SPRIGS FRESH ROSEMARY (FOR THE FAT)

*Step 1*

Remove a good amount of fat from around the neck. Remove and discard skin, and cut fat into 1-inch cubes. Add the fat to a saucepot with the water and rosemary. Cover and simmer on low heat for 3 hours. Strain and set aside. Combine the rest of the above ingredients in a large stockpot and add just enough water to cover. Bring to a slow rolling boil, then reduce to a simmer for 3 hours. Remove head and set aside. Strain liquid through a fine mesh strainer and reduce by half at a slow rolling boil. When the head is cool enough to handle but still hot, pick off all the meat and separate from the cartilage, bloodlines, and fatty bits. Be sure to get all the meat; there are some nice bits in the eye cavity. Remove tongue and peel off outer layer and discard. Rough chop and add to meat. Set the meat aside and continue to step 2.

*Step 2*

1 LEMON, ZESTED WITH MICROPLANE, JUICED, AND STRAINED
RESERVED PARSLEY LEAF, MINCED
2 TABLESPOONS FRESH THYME, MINCED
1½ TEASPOONS QUATRE ÉPICES
½ CUP RENDERED FAT
1 CUP REDUCED LIQUID FROM HEAD
¼ CUP GOOD DIJON MUSTARD
1 TABLESPOON FRESH CRACKED PEPPER
KOSHER SALT TO TASTE

Add the above ingredients to the meat, mix thoroughly, and season with salt to taste.

*Step 3*

Divvy up the meat evenly into glass jars. You can choose to put it in any size you desire. Be sure to pack the meat in tight, leaving no air pockets but enough room to add some fat. Top the jars with the remaining fat, seal, and let stand in the fridge overnight. Feel free to leave them unopened up to a week before enjoyment. Best served at room temperature with a fresh baguette, cornichons, pickled red onions, and a nice Dijon or whole grain mustard.

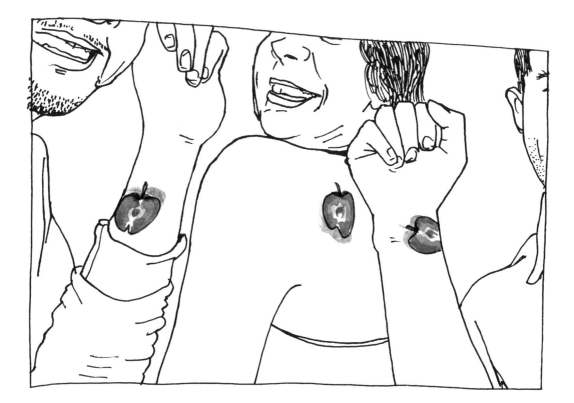

SENIOR SOUS CHEF
AT CASA LEVER
NEW YORK CITY, NEW YORK

# RICHARD ARTEAGA

BEING A CHEF IN NEW YORK CITY WASN'T EASY.
ESPECIALLY for SILVIA, WHO RECENTLY EMIGRATED
FROM ITALY. EVERY DAY WAS A CHALLENGE, and IT
FELT LIKE SOMEONE WAS ALWAYS TRYING TO SCREW HER
OVER. BUT WHILE WORKING HER FIRST JOB IN THE
U.S., SILVIA MET OSCAR and ME. WE STUCK BY EACH
OTHER'S SIDES THROUGH BAD and GOOD. WE LAUGHED,
CRIED, and ARGUED TOGETHER. WHEN WE STOPPED
WORKING with EACH OTHER, IT WAS A TEST TO OUR
FRIENDSHIP, BUT OUR BOND BECAME EVEN STRONGER.
I HAD THE IDEA THAT WE SHOULD GET A TATTOO TOGETHER
TO REPRESENT OUR RARE EVERLASTING FRIENDSHIP.
WHY AN APPLE? BECAUSE WE MET IN NYC. WHY THE
MOUNTAIN ROSE APPLE? BECAUSE IT'S AN HEIRLOOM APPLE
THAT ONLY GROWS for A SHORT PERIOD of TIME,
WHICH MAKES IT RARE, JUST LIKE OUR FRIENDSHIP.
PLUS, THE MOUNTAIN ROSE APPLE IS AN UNUSUAL
PINK LEMONADE COLOR ON THE INSIDE, and ITS TRUE
PINK COLOR PERSISTS THROUGH THE COOKING PROCESS,
WHICH REPRESENTS OUR STRONG BOND. NO MATTER WHAT
LIFE THROWS AT US, and HOW HARD THINGS MAY SEEM,
WE ALWAYS STAY TRUE TO OURSELVES and EACH OTHER.

# MARIELLE FABIE

I GOT THIS TATTOO RIGHT BEFORE I TURNED
TWENTY-THREE. AT THE TIME, I WAS
FEELING A TRIFECTA of EMOTIONS FROM
ALL OVER THE PLACE: THE END of A THREE-
YEAR RELATIONSHIP, MY GRADUATION FROM
CULINARY SCHOOL, and MY ACCEPTANCE
of A JOB OFFER AT A MICHELIN TWO-STARRED
RESTAURANT. I WANTED A TATTOO THAT
APPLIED TO MY CORE PHILOSOPHY WHEN IT
COMES TO BOTH LIFE and FOOD. IT'S A
REMINDER THAT INSTEAD of YEARNING for
MORE (MORE MONEY, MORE ACCOLADES,
MORE STARS), I SHOULD STRIVE TO BE BETTER.
CHOOSING QUALITY OVER QUANTITY IS
NOT ABOUT HAVING LESS, BUT HAVING MORE
of WHAT MATTERS MOST.

SOUS CHEF
AT ALEXANDER'S PATISSERIE
MOUNTAIN VIEW, CALIFORNIA

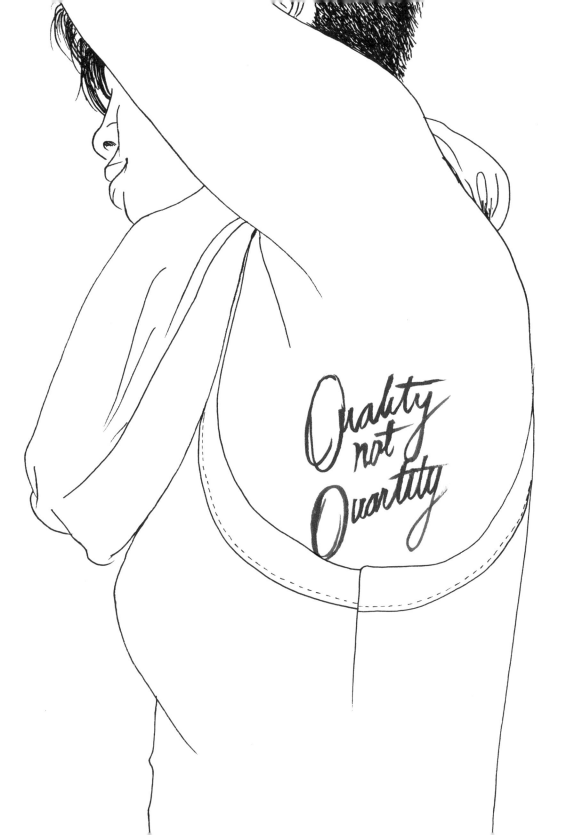

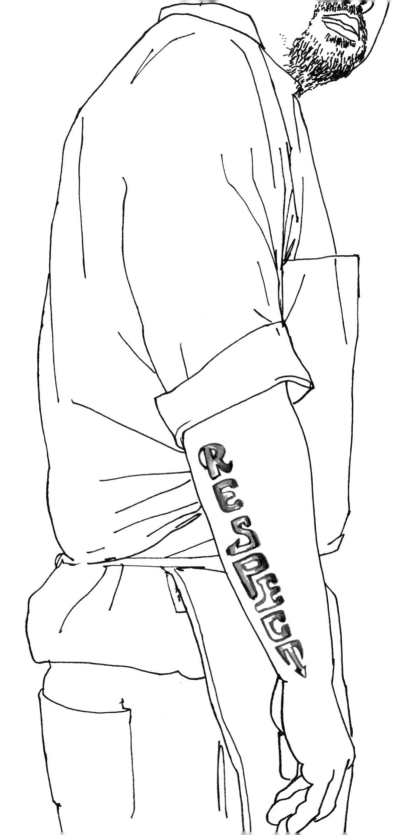

# MARK CRUZ

MY TATTOO IS A TRIBUTE TO MY FIRST
CHEF KNIFE. I WANTED TO INCORPORATE THE
WORD "RESPECT" for TWO REASONS. FIRST,
RESPECT WAS SOMETHING THAT WAS TAUGHT
TO ME FROM AN EARLY AGE. RESPECT
YOURSELF, RESPECT OTHERS, and OTHERS
WILL COME TO RESPECT YOU.

SECOND, RESPECT THE HARD WORK, BLOOD,
SWEAT, and TEARS FROM CHEFS PAST,
PRESENT, and FUTURE. RESPECT THE CRAFT,
RESPECT THE KNIFE.

KITCHEN SUPERVISOR
AT WATERFRONT MARRIOTT SFO
BURLINGAME, CALIFORNIA

# JENNIFER LYN PARKINSON

I TEXTED ALL MY FRIENDS and FAMILY and ASKED THEM, "IF YOU WERE A FRUIT OR VEGGIE, WHICH ONE WOULD YOU BE?" I STILL HAVE ALL MY FRIENDS FROM HIGH SCHOOL, and I HAVE MET MANY AMAZING PEOPLE ALONG THE WAY. EVERY SINGLE ONE of THEM HAS MADE ME WHO I AM TODAY, and EVERY SINGLE ONE of THEM TEXTED ME BACK A DIFFERENT ANSWER. IT'S MADE for A WONDERFUL TATTOO, and I AM VERY PROUD TO CARRY THEM ON MY ARM.

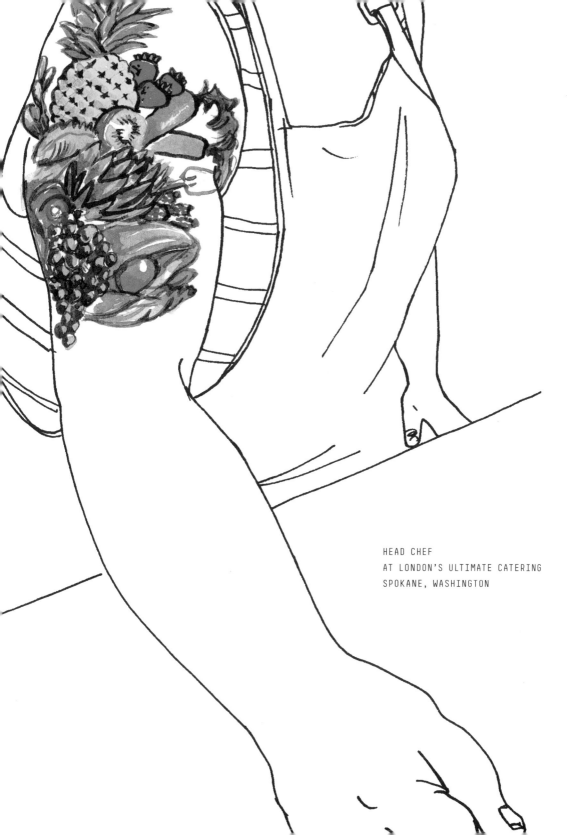

HEAD CHEF
AT LONDON'S ULTIMATE CATERING
SPOKANE, WASHINGTON

# ANGIE MAR

I DECIDED TO GET THIS BEE TATTOO WHEN I TOOK OVER THE HELM of MY FIRST KITCHEN. IT WAS SUCH A TROUBLED RESTAURANT AT THE TIME and NEEDED AN OVERHAUL DESPERATELY. BEES ARE NOT UNLIKE CHEFS, I SUPPOSE. WE WORK LONG GRUELING HOURS, CREATING A PRODUCT for ANOTHER'S ENJOYMENT. TO ME, THE BEE REPRESENTS A COLONY THAT WORKS AS A TEAM TO ACHIEVE ONE COMMON GOAL. EVERYONE KNOWS THEIR ROLE and WORKS TOGETHER. IT'S EXACTLY HOW A SUCCESSFUL

CLIFF SHAPIRO

KITCHEN SHOULD RUN. THE BEE ALSO REMINDS ME TO SLOW DOWN, FROM TIME TO TIME, and SAVOR THE SWEETNESS IN LIFE.

CLIFF SHAPIRO

EXECUTIVE CHEF AND PARTNER
AT THE BEATRICE INN
NEW YORK CITY, NEW YORK

# NICHOLAS HYCHE

MY TATTOO IS A FLEUR-DE-LIS . . . *and* IT IS UGLY
AS FUCK. IN MAY 2006, I WAS WORKING *for* A
HOTEL COMPANY. THEY SENT ME TO NEW ORLEANS TO
ASSIST IN THE REOPENING *of* A LARGE UPSCALE HOTEL,
POST-HURRICANE KATRINA. ONLY ABOUT 30 PERCENT *of*
THE ROOMS WERE FILLED, *and* ABOUT 50 PERCENT

OF THOSE WERE OCCUPIED BY DISPLACED HOTEL
EMPLOYEES WHO HAD LOST THEIR HOMES TO
THE DEVASTATION.

I WAS SENT *with* TWO OTHER PHOENIX-
AREA CHEFS TO HELP RELIEVE THE STAFF *and*
PREPARE *for* THE GRAND REOPENING GALA. THE
EIGHTY-HOUR WORK WEEKS PLUS AFTER-HOURS
ON BOURBON STREET MADE *for* AN EXHAUSTING
YET EXHILARATING EXPERIENCE. I WAS FALLING
IN LOVE *with* NEW ORLEANS, SO I DECIDED TO FIND THE
CLOSEST TATTOO PARLOR *and* GET THE CITY'S SYMBOL
PERMANENTLY ETCHED INTO MY SKIN. I WENT TO THE
SHOP *and* SPOKE TO AN ARTIST, WHO WAS GUNG HO
ABOUT TATTOOING A FLEUR-DE-LIS ON A VISITOR TO
HIS CITY. AFTER OUR CONSULTATION, I WENT BACK
TO MY ROOM TO GATHER MY MONEY *and* THEN RETURNED.
AS THE ARTIST STARTED HIS WORK, ...CONTINUED ON NEXT PAGE

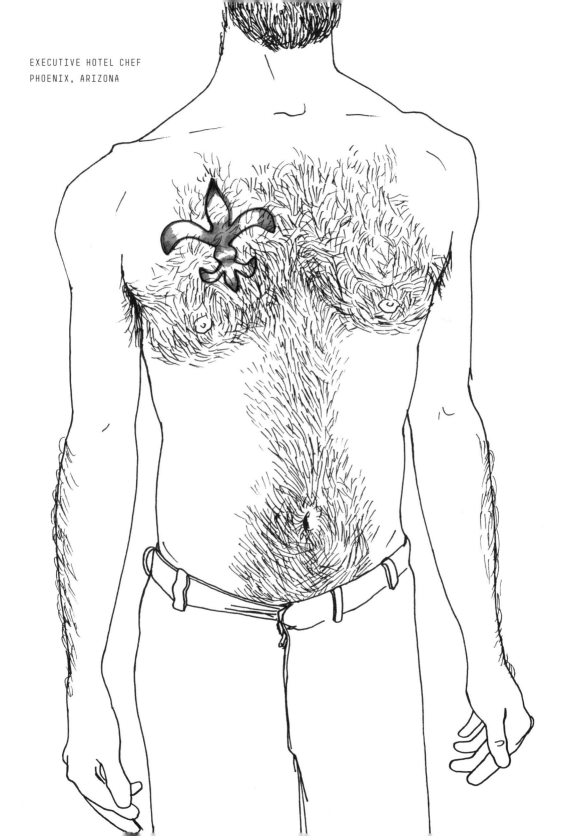

EXECUTIVE HOTEL CHEF
PHOENIX, ARIZONA

...CONTINUED FROM PREVIOUS PAGE I NOTICED THAT HIS DEMEANOR HAD CHANGED SINCE I WAS LAST THERE NOT FIFTEEN MINUTES BEFORE. HE WAS SHAKING, SLURRING, and TALKING TO HIMSELF, ALL THE WHILE STICKING A NEEDLE INTO MY CHEST. I'M FAIRLY CERTAIN HE HAD GOTTEN HIGH ON SMACK WHILE I WAS GETTING THE MONEY for THE TATTOO. (HENCE THIS TATTOO'S COMPLETELY SHITTY LINE WORK AND SHADING.) YET I LET HIM FINISH, THEN PAID and LEFT. HALF of ME WAS HEARTBROKEN, BUT THE OTHER HALF of ME SAW THE HUMOR IN IT. HERE I WAS, IN A LOVELY TOWN THAT WAS STILL IN SHAMBLES NINE MONTHS AFTER

HURRICANE KATRINA, with A HALF-ASSED VERSION of A FLEUR-DE-LIS ON MY CHEST. IT WAS QUITE FITTING. TO ME, IT'LL ALWAYS SERVE AS A REMINDER of THE RAWNESS OF THAT PLACE POST-CATASTROPHE: A CITY STRUGGLING, VERY FAR FROM PERFECT, BUT STILL STRIVING.

# AMANDA DOWNING

MY GRANDMA USED TO HAVE LILIES of THE VALLEY
GROWING ALONG THE SIDE of HER HOUSE WHEN I WAS
A CHILD. I HAVE ALWAYS LOVED THE SMELL of THESE
FLOWERS; THEY REMIND ME of HER. SHE LOVED THE SCENT

TOO, and EVEN WORE A LILY of THE
VALLEY PERFUME. THE FLOWERS SIGNIFY
"RETURN of HAPPINESS," WHICH HAS
PROVEN TRUE for ME. WHEN I GOT THIS
TATTOO, I HAD RECENTLY ENDED A TOXIC
LONG-TERM RELATIONSHIP, and AFTER-
WARD FOUND MYSELF RETURNING TO
THE THINGS THAT MAKE ME HAPPY IN LIFE.

EXECUTIVE CHEF AND PARTNER
AT ROCKIT BAR & GRILL
AND ROCKIT BURGER BAR
CHICAGO, ILLINOIS

# AMANDA DOWNING'S NOT YOUR MAMA'S TOT CASSEROLE

*For the tater tots*
12 LARGE BAKING POTATOES
4 TABLESPOONS KOSHER SALT
1 TABLESPOON FRESH GROUND BLACK PEPPER
3 TABLESPOONS EXTRA-VIRGIN OLIVE OIL
5 TABLESPOONS VEGETABLE OIL PLUS 2 CUPS FOR FRYING

Heat oven to 350° F. Wash potatoes well with water to remove all dirt. Lightly prick potatoes with a fork. Toss potatoes with 4 tablespoons vegetable oil and 2 tablespoons salt. Spread potatoes out on a large baking sheet. Roast until tender, about 1 hour. Remove from oven and allow to cool to room temperature, about 1 hour. Cut potatoes in half and press flesh through a baking grate into a large mixing bowl, leaving the skins separate. Season grated potatoes with 2 tablespoons salt and 1 tablespoon ground black pepper, then fold in 4 tablespoons olive oil. Line a half sheet tray with parchment paper and lightly grease with 1 tablespoon vegetable oil. Firmly press potato mix into sheet tray, pressing evenly. Cover with plastic wrap and allow to chill overnight.

Cut potatoes into about 1-inch squares. Heat 2 cups vegetable oil in a shallow fry pan to about 325° F. Carefully place potato squares into oil and fry until golden and crispy, flipping as needed and working in small batches so as not to crowd the pan. Remove from oil and drain on a paper-towel-lined plate.

*For the braised beef*
5 POUNDS TRIMMED BEEF SHORT RIB, CUT INTO 1-INCH PIECES
1 TABLESPOON TOMATO PASTE
1 YELLOW ONION, PEELED AND QUARTERED
1 CARROT, PEELED AND QUARTERED
1 STALK CELERY, QUARTERED
6 CUPS BEEF STOCK
24 OUNCES STOUT
1 SPRIG THYME
2 BAY LEAVES
1 TABLESPOON KOSHER SALT
½ TABLESPOON FRESH GROUND BLACK PEPPER
2 TABLESPOONS VEGETABLE OIL
2 TABLESPOONS CORNSTARCH, MIXED WITH COLD WATER TO FORM A PASTE

Heat oven to 325° F. Season beef short rib with salt and pepper. Heat a large Dutch oven over medium-high heat. Add 2 tablespoons vegetable oil, sear beef on both sides, working in batches, and remove from pot. Keep pot over medium heat, add in tomato paste, cook for 2 minutes, then add the onions, carrots, and celery. Brown slightly. Add the stout. Reduce heat to low, reduce slightly. Add the beef back to pot. Add beef stock. Bring to a simmer, cover, and braise in oven until tender, about 30 to 40 minutes.

Remove meat from braising liquid, strain liquid into a saucepan, bring to a boil, and whisk in cornstarch to thicken slightly.

*To assemble dish*
TATER TOTS
BRAISED BEEF
BRAISING LIQUID
2 CUPS COOKED PEARL ONIONS
2 CUPS QUARTERED AND COOKED CREMINI MUSHROOMS
2 TABLESPOONS BLACK TRUFFLE PASTE
2 TABLESPOONS HEAVY CREAM
1 CUP GRATED GRUYÈRE CHEESE

Heat oven broiler to medium high. Heat braised beef in a large sauté pan with pearl onions, mushrooms, and thickened braising liquid. Once hot, add in heavy cream and fold in truffle paste. Pour mix into metal dish, top with fried tater tots. Sprinkle Gruyère cheese over top. Bake under broiler until cheese is melted. Serve.

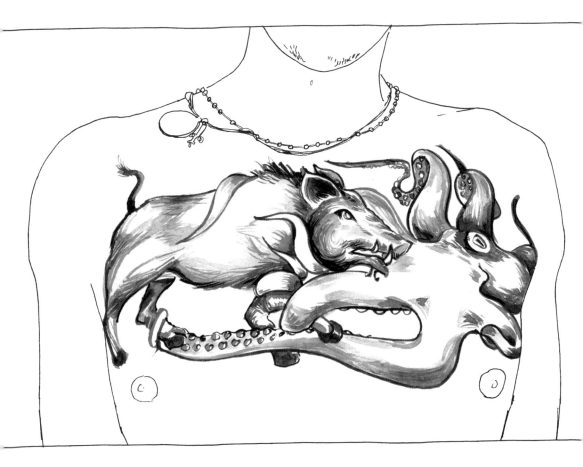

EXECUTIVE CHEF
AT PENROSE
OAKLAND, CALIFORNIA

# NATE BERRIGAN-DUNLOP

AS A CHEF, I WANTED TO GET A TATTOO THAT WOULD REPRESENT ONE of THE CLASSIC FOOD COMBINATIONS: SURF and TURF. I STARTED THINKING ABOUT WHAT ANIMALS WOULD BE THE COOLEST, ONE FROM THE LAND and ONE FROM THE SEA, and DECIDED THAT A WILD BOAR and AN OCTOPUS WOULD BE PERFECT. AND WHAT'S EVEN BETTER THAN A WILD BOAR and AN OCTOPUS? WHY, A WILD BOAR and AN OCTOPUS LOCKED IN BATTLE, of COURSE.

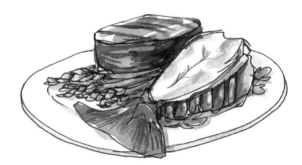

# JOE PALMA

WE HAVE AN OPEN KITCHEN AT MY RESTAURANT, and CUSTOMERS COME UP TO MY COUNTER and SAY, "HI, CHEF," ALL THE TIME. SINCE I'M COOKING, I CAN'T SHAKE THEIR HANDS, SO I USUALLY POUND THEM with MY FIST. I WANTED MY TATTOO TO BE IN A PLACE WHERE PEOPLE COULD SEE IT, A KIND of "HELLO" BACK AT THEM. I'M PROUD of MY JOB, and EVEN WHEN I'M NOT IN THE KITCHEN, I WANT TO SHOWCASE THAT PRIDE and COMMITMENT.

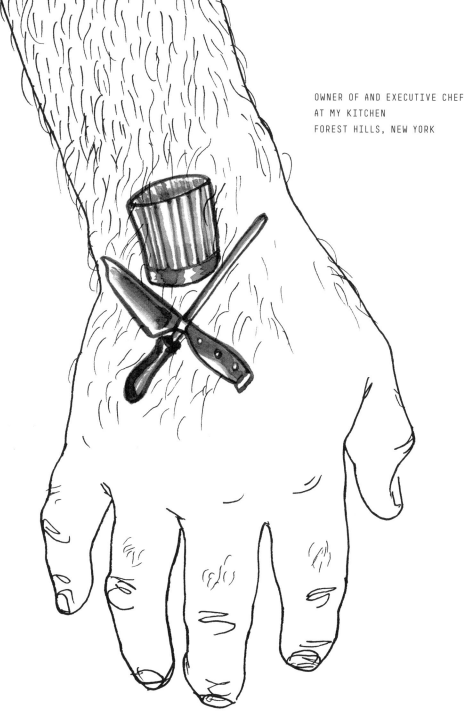

OWNER OF AND EXECUTIVE CHEF
AT MY KITCHEN
FOREST HILLS, NEW YORK

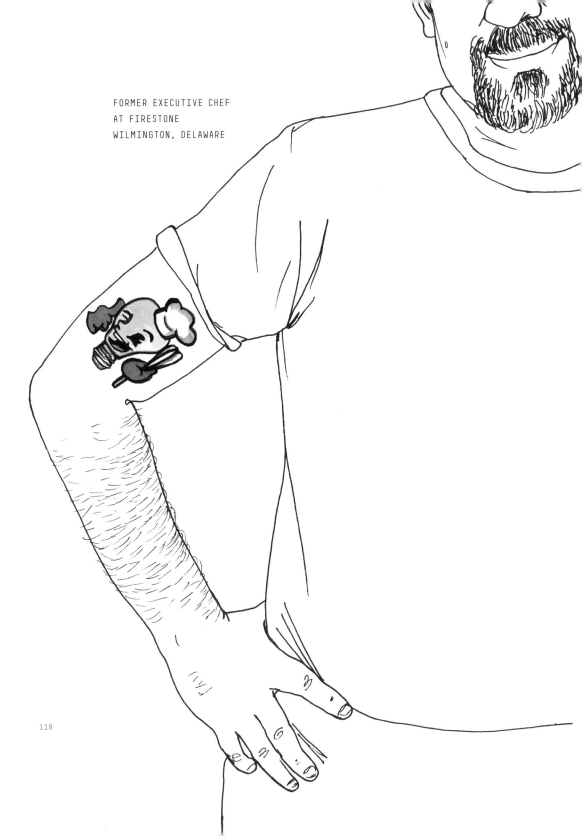

FORMER EXECUTIVE CHEF
AT FIRESTONE
WILMINGTON, DELAWARE

# JIM BERMAN

FOR MANY YEARS, I WAS A CHEF INSTRUCTOR AT A LARGE HIGH SCHOOL IN DELAWARE. ON ONE TERRIBLE SATURDAY, I GOT A PHONE CALL WHERE I LEARNED THAT ONE of MY JUNIORS HAD TAKEN HIS LIFE. A FEW DAYS PRIOR, MICHAEL HAD BEEN BATTLING BOUTS of ANXIETY, and MISSED SCHOOL THAT FRIDAY. ON SATURDAY MORNING, HE WENT TO WORK, MOWED HIS NEIGHBOR'S YARD, WENT UPSTAIRS TO HIS BEDROOM, and FASTENED A BAG OVER HIS HEAD with HIS FATHER'S BELT. MICHAEL WAS SEVENTEEN.

A GOOD FRIEND of MINE DID A TRIBUTE T-SHIRT THAT WOULD BE SOLD TO SUPPORT THE FUNDING of A TREE TO BE PLANTED IN MICHAEL'S MEMORY. THE IMAGE ON THE SHIRT WAS BASED ON ONE of MY FAVORITE SAYINGS: "THINK LIKE A COOK!" IN ESSENCE, USE YOUR BRAINPOWER TO FIND SOLUTIONS THAT ARE TIMELY, EFFECTIVE, and RELEVANT TO LIFE IN THE KITCHEN. ...CONTINUED ON NEXT PAGE

...CONTINUED FROM PREVIOUS PAGE THE LIGHTBULB REPRESENTS THE "AHA!" MOMENT. I MADE THE SHIRT IMAGE MY TATTOO TO HELP with THE HEALING PROCESS, SINCE AS A TEACHER, I HAD BEEN DEVASTATED BY THE LOSS of THIS VERY GENTEEL YOUNG MAN. AND AS A PARENT, I WAS HEARTBROKEN TO KNOW THAT MICHAEL'S PARENTS WERE BURYING THEIR SEVENTEEN-YEAR-OLD SON. HE WASN'T BULLIED. HE WASN'T ABUSED. HE WASN'T A RECLUSE. RATHER, HE WAS IN PAIN, and TOOK THE ONLY WAY OUT HE KNEW. MICHAEL HAD FIVE THOUSAND DOLLARS IN THE BANK FOR A NEW CAR and A LOCKER FULL of FOLDED CHEF COATS. HE HAD PLANS, BUT HIS DEMONS GOT THE BEST of HIM.

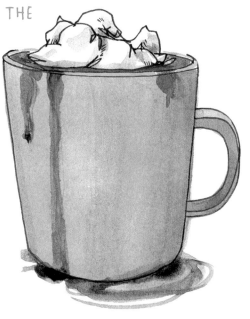

# JIM BERMAN'S HOT CHOCOLATE

Here is my take on classic hot chocolate. It is comforting and is the warm belly hug that cures all that ails you.

1 CUP SEMISWEET CHOCOLATE CHIPS
1 CUP HEAVY CREAM
2 CUPS WHOLE MILK
½ CUP GRANULATED SUGAR
1 TABLESPOON GOOD VANILLA EXTRACT
PINCH OF SALT
PINCH OF CINNAMON

Place chocolate in a heavy-bottomed saucepot and melt over medium-low heat. Once the chocolate melts, gradually stir in the cream, 1/2 cup at a time. When the cream is completely incorporated, add the milk, sugar, vanilla, salt, and cinnamon. Bring to a simmer; a simmer should cause the hot chocolate to quiver with life but not come to a hot-tempered boil.

*For the whipped cream*
2 CUPS HEAVY CREAM
¼ CUP GRANULATED SUGAR
1 TEASPOON OF THE SAME GOOD VANILLA EXTRACT

Pour the cream in a meticulously clean bowl, preferably stainless steel. Whip with a large, balloon-style whisk until it just starts to lose its liquid state and become something more of a semisolid. Add the sugar and vanilla. Continue whipping until the cream holds stiff peaks.

## NICK VENEZIA

I GOT THIS TATTOO AFTER LANDING A JOB
and LITERALLY RIGHT BEFORE I STAGED
AT THE GRAMERCY TAVERN IN MANHATTAN.
IT STILL HAD THE WRAP ON IT. HEAD
CHEF MICHAEL ANTHONY SAID IT WAS ONE
of THE MOST ORIGINAL TATTOOS HE'D
EVER SEEN, and ASKED ME WHY I GOT IT.
I REPLIED, "EVERY GOOD COOK HAS A SHARPIE
ON HIM AT ALL TIMES."

# NICK VENEZIA'S JALAPEÑO CAST-IRON CORN BREAD

```
8 LARGE EGGS
2 CUPS SUGAR
2 CUPS CORNMEAL
2 CUPS ALL-PURPOSE FLOUR
1⅓ CUPS MELTED BUTTER AND AN EXTRA DAB!
2 TEASPOONS KOSHER SALT
1 CUP HEAVY CREAM
1 LARGE SHALLOT, FINELY DICED
2 JALAPEÑOS (PREFERABLY 1 GREEN, 1 RED), FINELY DICED
ONE CAST-IRON PAN, PREFERABLY. WORKS IN A BAKING PAN AS WELL.
```

Sweat jalapeños and shallot in the dab of butter; remove from pan and let cool.

Beat the eggs and cream together. Combine the flour, sugar, cornmeal, and salt in a large bowl and mix. Add the liquid mixture to the dry. Stir in the butter and the shallot/jalapeños. Pour into a well-greased cast-iron pan.

Bake at 350° F till golden-brown delicious . . . roughly 20 to 25 minutes. Poke the center with a toothpick. It will be ready when the center is dry.

SOUS CHEF
AT THE SINCLAIR
CAMBRIDGE, MASSACHUSETTS

# DANNY BOWIEN

MY MOTHER WAS SUPER RELIGIOUS, and
COLLECTED ANGEL FIGURINES. SHE WAS SICK
MOST of MY CHILDHOOD, and PASSED AWAY
WHEN I WAS IN HIGH SCHOOL. AT THE AGE of
TWENTY I MOVED FROM OKLAHOMA CITY,
WHERE TATTOOS WERE ILLEGAL, TO SAN
FRANCISCO. I GOT THESE WINGS IN A TATTOO
PARLOR ABOVE A SUBWAY SANDWICH SHOP
IN THE CASTRO. THEY WERE EXPENSIVE and
I WAS BROKE, SO I HAD TO GET THEM ONE
AT A TIME, ABOUT A YEAR APART. THEY WERE,
and STILL ARE, MY WAY of ALWAYS
KEEPING HER with ME.

OWNER OF AND CHEF
AT MISSION CHINESE
AND MISSION CANTINA
SAN FRANCISCO, CALIFORNIA,
AND NEW YORK CITY, NEW YORK

# ANNA BARIE

I STARTED COOKING IN PARIS A LITTLE OVER TWO YEARS AGO.
I'M AMERICAN, BUT I TRAVELED for YEARS SINGING IN BANDS.
ON A EUROPEAN TOUR I FELL IN LOVE
with OUR BASQUE TOUR MANAGER.
WE GOT MARRIED and I
LEFT BROOKLYN for
FRANCE. MY FRENCH
WASN'T SO GREAT AT FIRST,
and I HAD A HARD TIME
FINDING A JOB. BUT I'VE BEEN
WORKING IN RESTAURANTS
SINCE I WAS
FIFTEEN, SO I
FINALLY FOUND
A PLACE THAT
NEEDED ENGLISH-
SPEAKING COOKS, and
I WENT FROM PEELING
POTATOES and CHOPPING
ONIONS TO WORKING ON THE
LINE. THE TOUR MANAGER
HUSBAND WAS TRAVELING A LOT, SO
I WAS OFTEN ALONE. THEN HIS DAD DIED

IN A CAR CRASH, and THIS REALLY DID BREAK THE FAIRY-TALE SPELL for BOTH of US. WE SPLIT UP. I STAYED ON IN PARIS ALONE, HEARTBROKEN and HOMESICK BUT STILL COOKING. THE KITCHEN SAVED MY LIFE. IT GAVE ME A SENSE of PURPOSE.

I LEFT for L.A. WHEN MY VISA RAN OUT. AROUND MY BIRTHDAY, WE HAD AN ART SHOW IN MY FRIEND'S FLAT. ONE PART of OUR PERFORMANCE WAS MY FRIEND CHLOE TATTOOING AN ALCHEMICAL SYMBOL ON BOTH of MY RING FINGERS. WE DID THIS WITHOUT SPEAKING TO EACH OTHER, AS I CHANTED QUIETLY TO MYSELF. I WAS LETTING GO of WHAT DIDN'T SERVE ME ANYMORE—of A DREAM THAT I HAD HAD ABOUT HOW MY 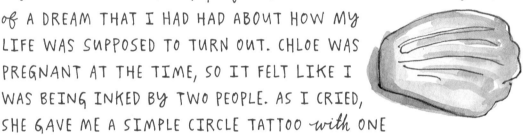 LIFE WAS SUPPOSED TO TURN OUT. CHLOE WAS PREGNANT AT THE TIME, SO IT FELT LIKE I WAS BEING INKED BY TWO PEOPLE. AS I CRIED, SHE GAVE ME A SIMPLE CIRCLE TATTOO with ONE LINE DOWN THE MIDDLE ON MY RIGHT RING FINGER. THIS SYMBOL WAS A SEED, OR THE START of A WHEEL. MY NEW LIFE. I'VE SINCE ADDED ANOTHER LINE, WHICH MAKES IT A CROSS IN A CIRCLE. IT'S AN EVOLVING TATTOO THAT WILL EVOLVE with ME for THE REST of MY LIFE, and I EVEN HAVE PLANS for THE FINAL LINE OF THE WHEEL TO BE DRAWN AFTER I'M DEAD.

LINE COOK
AT DUNE
LOS ANGELES, CALIFORNIA

# ANTHONY STRONG

MY FAVORITE TATTOO IS THIS ONE of PULCINELLA'S VOYAGE TO THE MOON. PULCINELLA IS A HERO of NEAPOLITAN FOLKLORE, A WILD MASHUP of CLOWN-LUNATIC-GENIUS-IDIOT-HERO. IN ONE TALE, HE BUILDS A SHIP, SAILS TO THE MOON, and RETURNS with CRAZY CREATURES, POTIONS, and INGREDIENTS TO COOK with.

IN NAPLES, YOU SEE PULCINELLA DEPICTED ON EVERYTHING FROM RESTAURANT SIGNS TO CHRISTMAS ORNAMENTS. WHILE I WAS STAGING AT A RESTAURANT THERE, I VISITED A GREAT LITTLE BOOKSTORE, WHERE I FOUND SOME STELLAR OLD NEAPOLITAN COOKBOOKS, and ALSO CAME ACROSS THE PRINTS THIS TATTOO IS BASED ON. I BOUGHT FOUR SETS of THE PRINTS—ONE for HOME, THE OTHER THREE for MY RESTAURANTS. BUT EVEN THAT WASN'T ENOUGH. I LOVED THEM SO MUCH, I HAD THEM TATTOOED ON ME WHEN I RETURNED HOME TO SAN FRANCISCO.

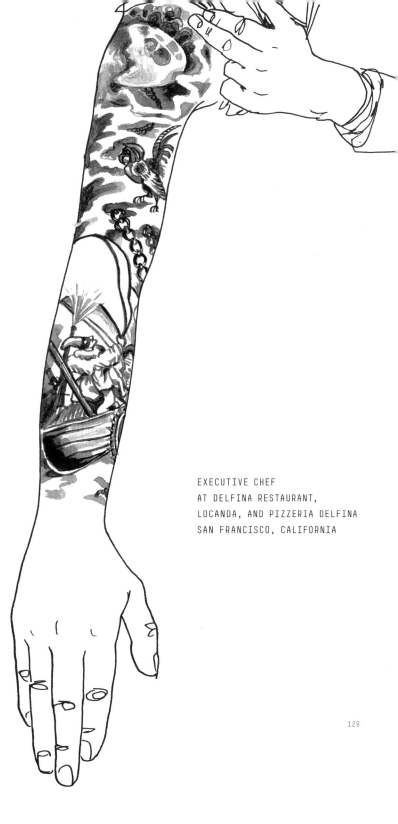

EXECUTIVE CHEF
AT DELFINA RESTAURANT,
LOCANDA, AND PIZZERIA DELFINA
SAN FRANCISCO, CALIFORNIA

## ANTHONY STRONG'S SHELLING BEANS with SOFFRITTO and XVOO

*Serves 4*

3 CUPS FRESH OR DRIED SHELLING BEANS
2 GARLIC CLOVES, PEELED
4 TO 5 SAGE LEAVES
1 YELLOW ONION
4 STALKS CELERY
1 SMALL CARROT
½ BUNCH SAGE, FINELY MINCED
½ BUNCH ROSEMARY, FINELY MINCED
3 GARLIC CLOVES, PEELED AND LIGHTLY CRUSHED
EXTRA-VIRGIN OLIVE OIL
KOSHER SALT
BLACK PEPPER

If using dried beans: One day ahead, cover the beans with cold water and soak overnight in the refrigerator.

4 to 5 hours ahead: Place the soaked beans, garlic, and sage leaves in a large pot, cover with a generous amount of water, and add a pinch of salt. Over a low flame, cook very slowly (very, very slowly), ensuring that they never come to a boil. Begin to check for doneness after a half hour or so, as different beans cook at different rates. They will be ready when the skin is soft and the inside is completely creamy. Add another pinch of salt and cool the beans, in just enough of their cooking liquid to cover, until ready to serve.

Meanwhile prepare the soffritto: Finely mince the onion, celery, and carrot. Using a wide sauté pan large enough to accommodate the vegetables in a shallow layer, slowly heat a large splash of olive oil and the crushed garlic cloves, cook for a minute or two, and then increase the heat to medium-high; add in the onions, celery, and carrot, a big pinch of salt, and sauté, tossing constantly in the pan to ensure they don't color. Add a small spoonful of water. When the soffritto is almost translucent, add in the minced rosemary and sage and cook a minute longer. The soffritto is perfectly cooked when there is just a hint of crunch left. Spread the mixture thinly on a plate and cool.

To finish: Remove the garlic cloves from the beans and soffritto. Warm the beans over medium heat in just enough of their liquid to cover. Using the back of a large spoon, crush just a dozen or so of the beans completely against the side of the pot to release some of their starch into the water. Cook the beans until the whole mixture becomes very thick and stew-like; season them to taste with salt. At the very last second, add in the soffritto and an absurdly generous amount of olive oil, stir to incorporate. There should be enough starch in the thick bean liquid at this point to completely emulsify in the olive oil and make the stew very creamy. If the mixture is too thick, or if they appear oily, a splash or two of water might be necessary to re-bind everything together.

Transfer to a serving dish (or just eat them straight out of the pot) and finish with lots of cracked black pepper.

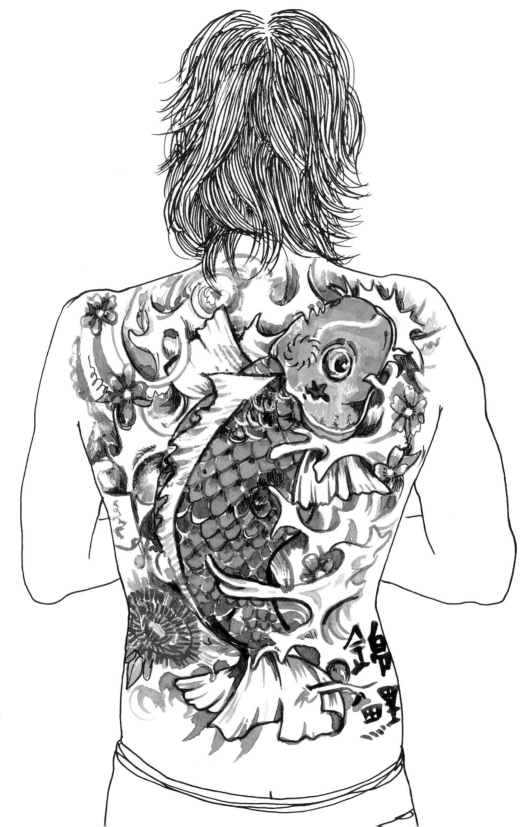

# BRAXTON YOUNTS

I GOT THIS TATTOO AFTER I SPENT TIME IN
JAPAN, VISITING MY THEN-GIRLFRIEND WHO
WAS TEACHING ENGLISH IN TOKYO. SWIMMING
UPSTREAM, THE MASSIVE KOI REPRESENTS
PERSEVERANCE, AS WELL AS HUMILITY IN THE
FACE of LIFE'S MANY OBSTACLES. THOUGH
THE WOMAN I WAS VISITING and I ARE NO
LONGER ROMANTICALLY INVOLVED, MY SKIN
RETAINS MEMORIES of OUR TIME TOGETHER.
RELATIONSHIPS, LIKE KITCHEN JOBS, REQUIRE
PERSEVERANCE, and NEITHER ARE for
THE EMOTIONALLY OR PHYSICALLY FRAGILE.

FORMER LINE COOK
AT THE QUEENS KICKSHAW
QUEENS, NEW YORK

# ROZE TRAORE

I WAS BORN with A HEART CONDITION and
NEEDED TO HAVE OPEN HEART SURGERY
TWICE TO REPLACE A VALVE. AFTER MY SECOND
HEART SURGERY I WANTED A REMINDER
of HOW LIFE REALLY IS LIVED "BEAT BY BEAT,"
WHICH IS WHAT THE TATTOO SAYS, and
NEVER TO TAKE A SINGLE DAY ABOVEGROUND
for GRANTED.

PRIVATE CHEF
NEW YORK CITY, NEW YORK

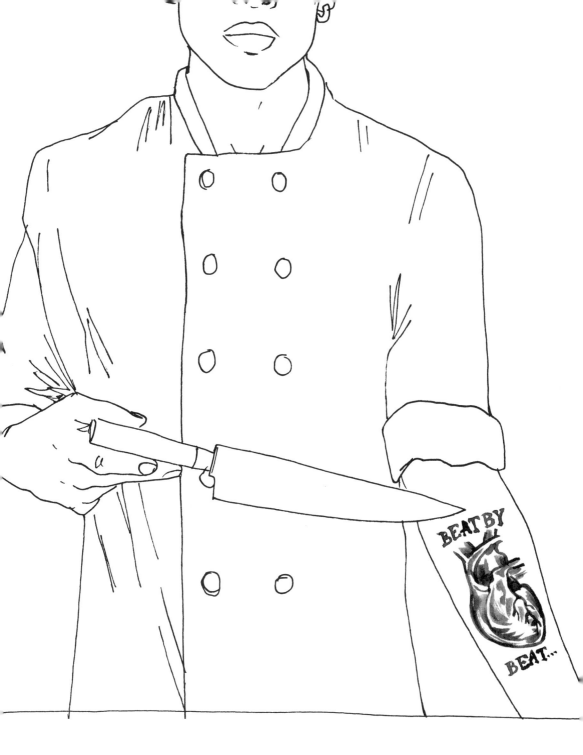

I came up with this dish as I was cooking for a client in London. Originally I would use couscous as the bed, but adding the Gemelli pasta took it to another level.

*Serves 5*

2 STICKS BUTTER
2 LEMONS
1 POUND GEMELLI PASTA
SAGE
SALT
PEPPER
1 POUND SHIITAKE MUSHROOMS
SHAVED PARMESAN CHEESE
1 POUND SALMON

# ROZE TRAORE'S BROWN-BUTTER SAGE SALMON *with* GEMELLI PASTA

*Mushrooms*
Heat pan, add olive oil and then mushrooms. Salt and pepper and finish with a squeeze of lemon.

*Brown butter*
Add butter and sage to your pan. Turn heat on low and cook until brown.

*Gemelli pasta*
Season a large pot of water with 1 tablespoon of olive oil and plenty of salt. Bring to a boil and add your pasta. After 15 minutes, strain pasta when it is still al dente. Incorporate pasta with brown butter in pan and toss.

*Salmon*
Cut, season with salt and pepper. Heat your pan and add olive oil. Place your salmon in the pan skin-side down. Keep your heat at a medium level. Once there is a nice crispy skin, place pan in the oven for 7 minutes at 350° F.

*Plating*
Add your pasta and mushrooms to the center of the plate. Shave Parmesan cheese and lemon zest over the pasta and top with salmon.

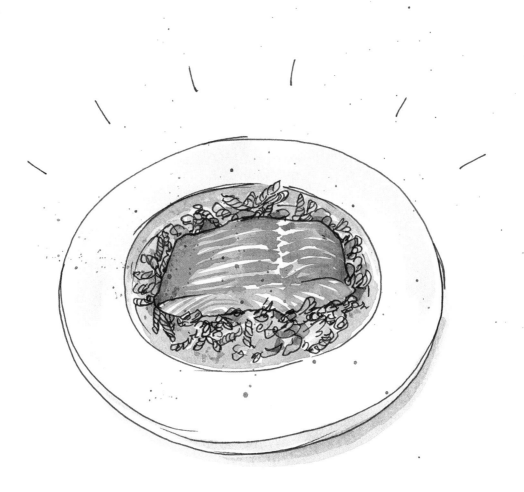

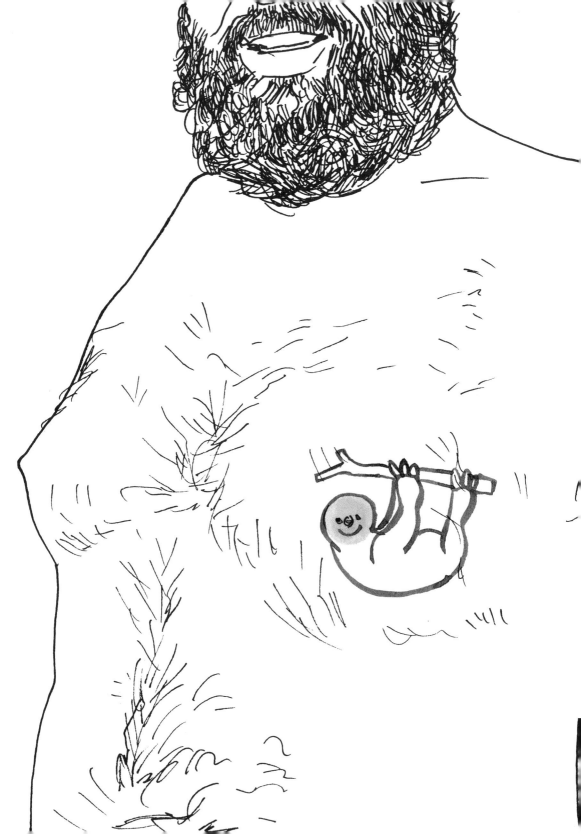

# ALDEN ULERY

MOST of MY LIFE HAS BEEN SPENT IN KITCHENS. IT
HAS BEEN, AS SO MANY LIVES SPENT IN KITCHENS ARE,
A LIFE FUELED BY DRUGS and ALCOHOL. AT A YOUNG
AGE I GOT INTO THE BAND PHISH. EARLY ON, THEIR
SHOWS WERE JUST A PLACE for ME TO GET FUCKED UP.
THEN, SLOWLY, I FELL IN LOVE with THE MUSIC.
FAST FORWARD SIXTEEN YEARS TO MY THIRTY-SECOND
BIRTHDAY: I'M NOW HAPPILY CLEAN and SOBER, STILL
SEEING MY FAVORITE BAND AS OFTEN AS POSSIBLE, and

TO COMMEMORATE THEIR
MUSIC, ON MY BIRTHDAY
I DECIDED TO GET A TATTOO
of A SLOTH, INSPIRED BY
THE NAME of ONE of MY
FAVORITE PHISH SONGS.

FORMER CHEF
AT THE LOAF AND LADLE
PORTSMOUTH, NEW HAMPSHIRE

# ALDEN ULERY'S OATMEAL

This is what I cook at breakfast for my wife and daughter as often as possible.

*Serves 2 to 4 depending on your appetite and toppings*

3½ CUPS WHOLE MILK
2 CUPS OLD-FASHIONED OATS
⅓ CUP HONEY
2 TABLESPOONS RED MISO
2 TEASPOONS CHINESE FIVE-SPICE POWDER
½ TEASPOON GROUND CARDAMOM
¼ TEASPOON GROUND ALLSPICE

In a medium-sized pot (4 quart?) on high heat bring oats and milk to a boil (3 minutes?). Once it boils, lower the heat to drop it to a simmer. Stirring enough to not scald the milk, let this cook and thicken until velvety. Mix in the rest of the ingredients.

I like to top with honeycrisp apples or figs when in season. Otherwise I will reach for dried apricots, craisins, golden raisins, pistachios, maybe a dollop of whipped butter.

OLD-
SCHOOL
STYLE

# CLINT IVES

I GOT THIS TATTOO of MY FIRST JAPANESE
CHEF KNIFE DIRECTLY AFTER GETTING
KICKED OUT of CULINARY SCHOOL. I HAD
BEEN COOKING for YEARS and WAS NOT GOING
TO LET GETTING THE BOOT FROM SCHOOL
STOP ME FROM BECOMING A CHEF. GETTING
THIS TATTOO WAS MAKING THAT COMMITMENT
TO MYSELF IN A PERMANENT WAY.

I MANAGED TO HIDE THE TATTOO FROM MY
DENTIST FATHER for SIX MONTHS. WHEN HE
FINALLY DID SEE IT . . . . SURPRISE, SURPRISE,
MY FATHER LOVED IT SO MUCH HE THOUGHT
ABOUT GETTING A SIMILAR ONE of A DENTAL
SCALPEL. HE HASN'T TAKEN THE LEAP YET,
BUT MAYBE ONE DAY.

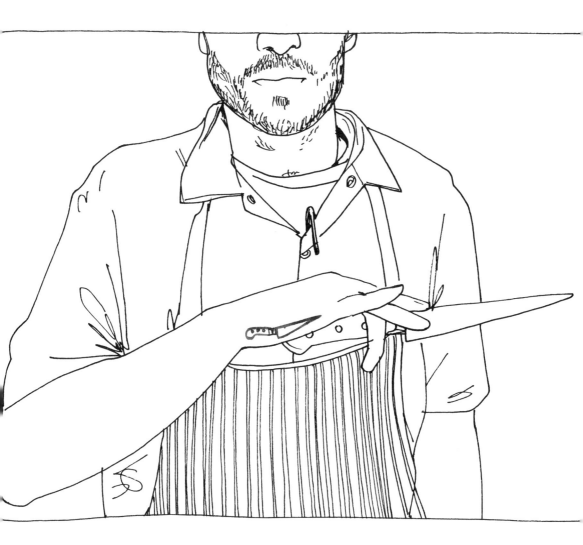

SOUS CHEF
AT CHERCHE MIDI
NEW YORK, NEW YORK

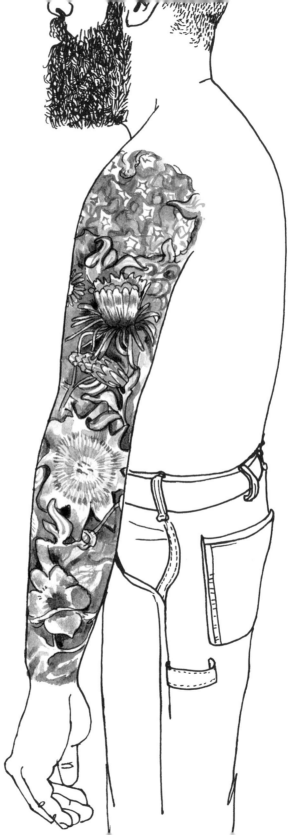

OYSTER SHUCKER
AND PASTRY ASSISTANT
AT EVENTIDE OYSTER CO.
PORTLAND, MAINE

# BRANT DADALEARES

I'VE WORKED IN KITCHENS SINCE I WAS
FOURTEEN and I'VE BEEN A PASTRY CHEF for
THE LAST EIGHT YEARS. I HAVE TWO FULL
SLEEVES: THIS ONE IS PLANT LIFE and THE
OTHER IS SEA LIFE. THE SLEEVE IS BUILT
AROUND A HOYA VINE, WHICH BLOOMS ON MY
SHOULDER. STARTING AT THE WRIST, THE
FLOWERS ARE: A PHALAENOPSIS ORCHID, AN
ANTHURIUM, A COLUMBINE, A WATER LILY,
TWO SOLANDRA MAXIMAS IN VARYING AGES,
FALL BLOOMING ASTERS, A TREE PEONY,
A PASSION FLOWER ON MY ELBOW, A CEREUS,
and FINALLY THE HOYA BLOOM ON TOP.
THESE ARE ALL PLANTS THAT I'VE GROWN IN
THE PAST OR GROW NOW, AS MY OTHER
PASSION IN LIFE IS GARDENING.

# BRANT DADALEARES'S BROWN SUGAR–CREAM CHEESE ICE CREAM *with* ORANGE-CARDAMOM-*and*-BACON-FAT CHOCOLATE CRUMB

*Brown-sugar cream cheese ice cream*
379 GRAMS WHOLE MILK
162 GRAMS CREAM CHEESE AT ROOM TEMPERATURE
128 GRAMS DARK BROWN SUGAR
55 GRAMS GRANULATED SUGAR
5 GRAMS KOSHER SALT
123 GRAMS EGG YOLKS AT ROOM TEMPERATURE
½ TEASPOON VANILLA EXTRACT

Set up an ice bath by placing a large bowl on top of another bowl filled with ice. Place a fine mesh strainer in top bowl.

Place cream cheese and egg yolks in two separate bowls.

In a heavy-bottomed saucepan, heat milk, dark brown sugar, granulated sugar, and salt to a simmer, making sure all sugar is dissolved. Pour enough of the hot milk mixture over the cream cheese to cover. Let this sit for 5 to 6 minutes undisturbed.

Slowly add the remaining milk mixture to the egg yolks while whisking. Whisk the cream cheese smooth, then add that mixture to the egg yolk mixture. Pour all of the ice cream base back into the saucepan and cook over medium heat while stirring constantly with a wooden spoon until thickened, coating the back of the spoon and reaching 180° F. Whisk in vanilla extract. Strain the ice cream base into the ice bath. Chill for at least two hours.

Churn in ice cream maker according to manufacturing instructions. Place ice cream in freezer for at least four hours to set.

*Orange-cardamom-and-bacon-fat chocolate crumb*

4 THICK-CUT SLICES OF APPLEWOOD SMOKED BACON, COOKED
  AND FAT RESERVED SEPARATELY
140 GRAMS ALL-PURPOSE FLOUR
.5 GRAMS GROUND CARDAMOM
4 GRAMS ORANGE ZEST
37.5 GRAMS COCOA POWDER
70.5 GRAMS GRANULATED SUGAR
84 GRAMS DARK BROWN SUGAR
14.5 GRAMS CORNSTARCH
16.5 GRAMS KOSHER SALT
110 GRAMS COLD BUTTER, DICED
20 GRAMS OF RESERVED WARM APPLEWOOD-SMOKED BACON FAT

Preheat oven to 340° F.

Eat the bacon.

Line a half sheet pan with parchment paper. In the bowl of a food processor blend the flour, cardamom, zest, cocoa powder, both sugars, cornstarch, and salt for two minutes or until very well combined. While pulsing, add in the cold butter until thoroughly combined. Place mixture into a bowl and, while working with your hands, slowly add smoked bacon fat and incorporate well to create crumbs. Pour crumb onto sheet pan and chill in the refrigerator for one hour.

Bake crumb for 10 minutes and give the crumb a stir. Bake for an additional 6 minutes, remove from the oven, and let cool without stirring. Store in a sealed container. Be careful, this shit is addictive. Serve with brown sugar-cream cheese ice cream.

# ERIC C. EHLER

THE TATTOO IS for MY CHILDHOOD BEST
FRIEND, MASON PIERCE LEONARD. WE GREW UP
IN A SMALL IOWA TOWN of ONE THOUSAND
PEOPLE CALLED HOLSTEIN, AFTER THE COW.
  WE STARTED SKATEBOARDING WHEN WE
WERE ABOUT NINE. WE CONTINUED TO SKATE
INTO OUR HIGH SCHOOL DAYS, WHICH IS
WHEN WE GOT INTO PLAYING MUSIC and
STARTED THE WORLD'S WORST GARAGE PUNK
BAND. WE BOTH WENT TO COLLEGE IN 2006.
ME TO CULINARY SCHOOL, and HIM TO IOWA
STATE UNIVERSITY. I STARTED PARTYING
A LOT, and HE STAYED STRAIGHT EDGE;
WE GREW APART. FOR TWO YEARS, WE DIDN'T
HANG OUT VERY OFTEN. BUT THE MONTH
BEFORE HE PASSED, WE ATTENDED A MUSIC
SHOW TOGETHER IN OMAHA. IT WAS A GREAT
REUNION for US. I REALIZED HOW MUCH
I MISSED KICKING IT with MY FRIEND. I
MADE IT A GOAL TO STOP DRINKING SO MUCH,
and MAKE TIME for SKATING and PLAYING
MUSIC with MASON. ...CONTINUED ON NEXT PAGE

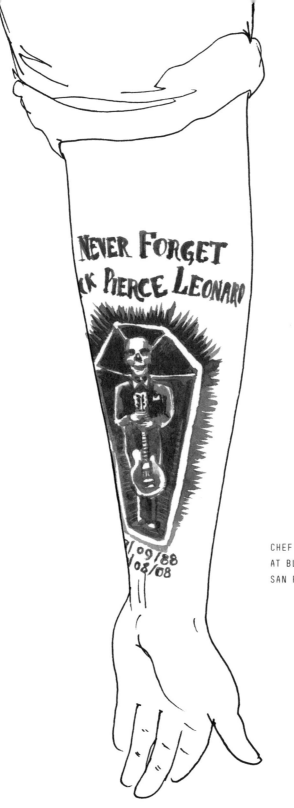

NEVER FORGET
CK PIERCE LEONARD

/09/88
/08/08

CHEF
AT BLACK SANDS BREWERY
SAN FRANCISCO, CALIFORNIA

...CONTINUED FROM LAST PAGE A FEW WEEKS LATER, AFTER A LONG NIGHT of PARTYING— BECAUSE SOME HABITS TAKE A WHILE TO CHANGE—I WOKE UP HUNGOVER and STRUNG OUT TO DOZENS of PHONE CALLS and TEXTS. MASON HAD BEEN KILLED IN A CAR CRASH; THE DRIVER of THE OTHER CAR WAS DRUNK.

THAT MORNING MY LIFE BASICALLY FELL APART. I SPENT THE NEXT FEW MONTHS IN A DEEP DARK HOLE. AFTER FINISHING CULINARY SCHOOL IN THE FALL, I RAN AWAY. I SPENT TIRELESS HOURS SENDING OUT RESUMES and APPLICATIONS TO KITCHENS ACROSS THE COUNTRY. EVENTUALLY I LANDED A JOB IN SAN FRANCISCO, and MOVED THERE FROM IOWA.

SHORTLY AFTER, I GOT THIS TATTOO. I WANTED TO BE REMINDED for THE REST of MY LIFE of WHAT AN AMAZING FRIEND I HAD, and WHAT A POOR FRIEND I HAD BEEN LEADING UP TO HIS DEATH. I WANTED A REMINDER TO LIVE for MASON, TO LIVE A FULFILLING LIFE IN HONOR of THE ONE THAT HAD BEEN STOLEN AWAY FROM HIM.

# ERIC C. EHLER'S SIKIL P'AK AKA PUMPKIN-SEED HUMMUS

For the past seven years, I have been working in kitchens in San Francisco, largely supported by Mexican cooks from the Yucatan Peninsula. They are of Mayan heritage; they speak the dead language and are lovers of food and drink. The way I have been able to connect with them has been by learning to cook the cuisine specific to their homeland. The Mayans have a tendency to char or burn their ingredients. You can find something of the such in most braises, salsas, or dips. This one is a crowd favorite at Black Sands. It resembles chopped liver, but has a wonderfully nutty and roasty flavor. It goes great with any sturdy chip, especially taro chips.

*Makes about 2 1/2 quarts*

1.5 QUARTS PEPITAS
4 TOMATOES, CHARGRILLED
1 BUNCH SCALLIONS, CHARRED
5 GARLIC CLOVES, SLICED
1 RED ONION, CHOPPED
1 BUNCH CILANTRO
2 LIMES, JUICED
1 CUP OIL
½ CUP WATER
SALT

Pan roast pepitas in oil until dark browned; do this in batches. Grill tomatoes until cooked through and slightly charred. Grill scallions until golden brown, almost black, in the pan used to roast pepitas. Brown onion and garlic. Process 3/4 of the pepitas in a food processor with other ingredients. Process the rest of the pepitas separately. Mix everything together, and season with salt. Mixture should be coarse and resemble chopped chicken liver.

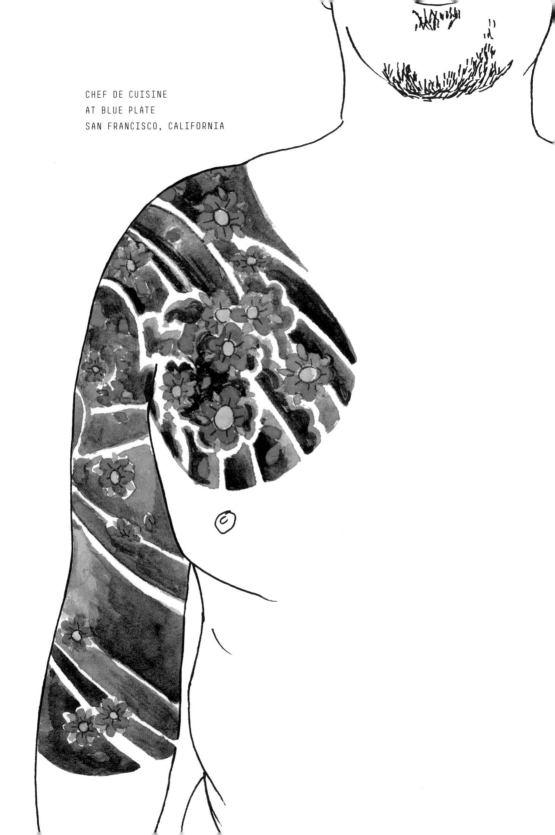

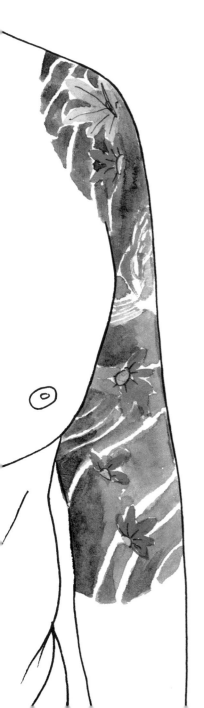

# SEAN THOMAS

THEY'RE JUST PRETTY.

# MEREDITH PITTMAN

WHEN I WAS TWENTY, I MOVED TO ST. THOMAS *for* THE SUMMER. ST. THOMAS WAS MY SAFE PLACE. THE PLACE I COULD RUN AWAY TO *for* A FEW WEEKS *and* GET MY HEAD STRAIGHT, WHERE MY ONLY WORRY WAS WHICH FLAVOR *of* RUM I WAS GOING TO SHOOT NEXT. EVERY CHRISTMAS, I'D GO BACK THERE TO WORK.

 I GOT THE TATTOO WHEN I WAS TWENTY-FOUR. FIVE MONTHS INTO CULINARY SCHOOL, I FELT COMPLETELY LOST. I WAS SO TORN BETWEEN BEING THAT CUTE SOUTHERN BAKER *and* REALLY STEPPING OUT *of* MY COMFORT ZONE. I HADN'T FOUND MY NICHE IN MEMPHIS OR SCHOOL OR IN A NEW RELATIONSHIP I WAS TOYING *with*.

NONE of MY OLD SORORITY FRIENDS UNDERSTOOD. THEY HAD ALL
GONE TO SCHOOL for THEIR "MRS. DEGREE" and WERE NOW
WORKING IN BOUTIQUES and WRAPPED UP IN STARTING FAMILIES.
I HAD NO ONE TO TALK TO and DOUBTED MYSELF and MY
DECISIONS DAILY.

    THAT CHRISTMAS, I COULDN'T MAKE IT TO ST. THOMAS BECAUSE
of SCHOOL. WHEN I REALIZED HOW MUCH I WAS MISSING
THE ISLAND, I DECIDED TO GET A PIECE DEDICATED TO IT. THE WAVE
CRASHING REPRESENTS ALL of MY EMOTIONS THAT I WAS
DEALING with AT THE TIME. LA DOLCE VITA MEANS "THE SWEET
LIFE," WHICH IT DEFINITELY IS DOWN ON THE ISLAND, and
IS ALSO THE NAME of THE BOAT THAT ACTED AS MY HOME BASE
MY FIRST SUMMER THERE. NOW I GET TO CARRY A SLICE of
THE SWEET LIFE WHEREVER I AM.

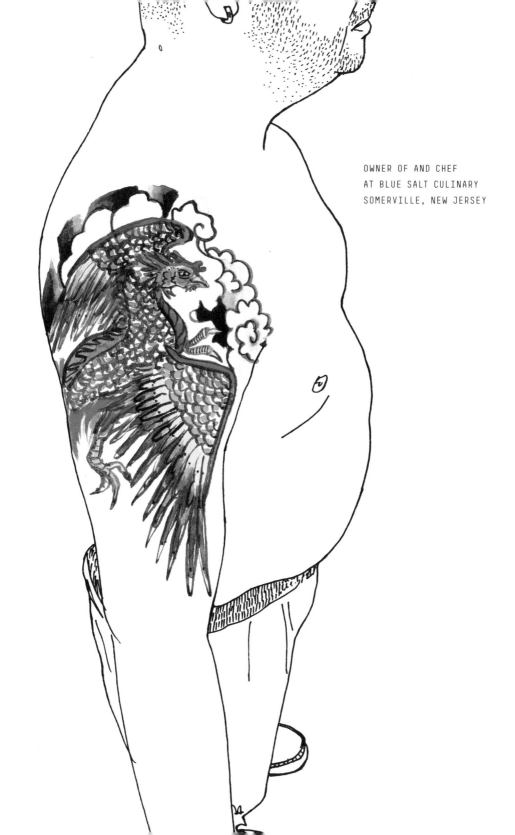

OWNER OF AND CHEF
AT BLUE SALT CULINARY
SOMERVILLE, NEW JERSEY

# SEAN PACKAN

BEFORE I EVER HAD ANY INK, I ALWAYS WANTED A PHOENIX TATTOO. I LOVE WHAT THEY REPRESENT. PHOENIXES SYMBOLIZE THE TRIUMPH FOUND IN REBIRTH and RENEWAL.

I HAD BEEN GOING THROUGH THE ABSOLUTE WORST TIME IN MY LIFE. MY FATHER HAD PASSED AWAY

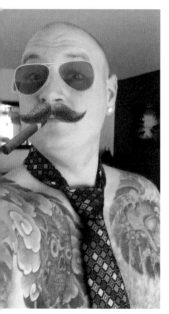

FROM LUNG CANCER. HE WAS THE ONE WHO HAD PAID for MY CULINARY SCHOOL EDUCATION. THEN I GOT LET GO FROM MY FIRST EXECUTIVE CHEF JOB, and MY GIRLFRIEND LEFT ME. ALL of THIS HAPPENED WITHIN THE SPAN of TWO MONTHS. I HAD HIT ROCK BOTTOM. AFTER BEING BROKE and SUPER DEPRESSED for A WHILE, I FINALLY FOUND A GOOD JOB. I STARTED MAKING SOME MONEY and WAS FINALLY READY for MY PHOENIX TATTOO. IT TOOK JUST UNDER A YEAR TO COMPLETE, and IS A PERFECT REPRESENTATION of WHAT I HAD GONE THROUGH: I WAS STRIPPED DOWN TO NOTHING, THEN FORCED TO REBUILD MYSELF FROM THE GROUND UP.

# MICHAEL GUNDLACH

TWO BUDDIES of MINE and I GOT MATCHING TATTOOS TO MARK OUR TIME AS FRIENDS, CHEFS, and CO-LEARNERS of OUR GREAT CRAFT. IT'S INSPIRED BY THE ROD of ASCLEPIUS, THE SYMBOL of HEALING and MEDICINE. I KNOW THAT SOUNDS HIGH-HORSED, BUT WHEN YOU COOK for PEOPLE, YOU TAKE CARE of THEM. MAKING GREAT FOOD and BEING SPECIAL IS GOOD, BUT SO IS TAKING CARE of PEOPLE AND MAKING THEM FEEL SPECIAL. THOSE THINGS AREN'T MUTUALLY EXCLUSIVE. SO OUR VERSION of THE ROD OF ASCLEPIUS IS IN RECOGNITION THAT WE MAKE THE STUFF, PEOPLE EAT THE STUFF, and THUS WE NEED EACH OTHER. JUST LIKE ALL THREE of US NEED EACH OTHER. WE ALSO USE A BUNCH of DUCK WHEN WE COOK, SO . . . DUCK SNAKES!

CHEF
AT THE DIRTY TRUTH
NORTHAMPTON, MASSACHUSETTS

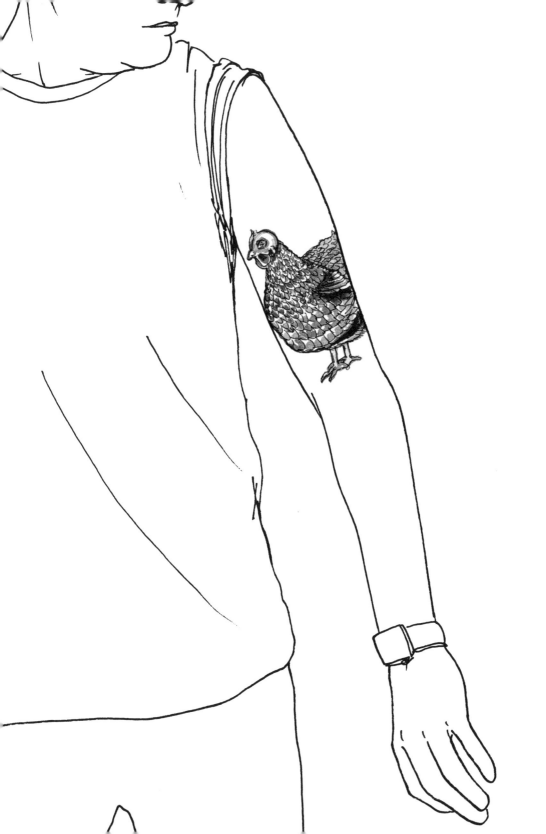

FOUNDER
OF TILIT CHEF GOODS
NEW YORK CITY, NEW YORK

# ALEX McCRERY

MY CHICKEN WAS INSPIRED BY A COUPLE of THINGS. FIRST, I LOVE BIRD TATTOOS. SECOND, AS A CHEF, I THINK THE CHICKEN IS SUCH AN INTEGRAL COMPONENT of AMERICAN FOOD CULTURE. BUT BECAUSE of THE ABUNDANCE of COMMERCIALLY FARMED POULTRY IN OUR COUNTRY, MOST PEOPLE AREN'T AWARE of THE VARIOUS BREEDS of BIRDS and HOW AESTHETICALLY BEAUTIFUL THEY ARE. THE TATTOO ON MY ARM REFERENCES THE GOLDEN LACED WYANDOTTE HEN, ONE of MY FAVORITES, WHICH ORIGINATED IN THE U.S. IN THE 1870s.

# KEVIN WARREN

UNDERNEATH MY FOREARM IS THE WORD "JUSTICE." IT'S MY LARGEST TATTOO. MY DEFINITION of JUSTICE IS BALANCE, MAKING SURE THAT THE PEOPLE WHO NEED HELP THE MOST GET THE MOST CONSTRUCTIVE HELP.

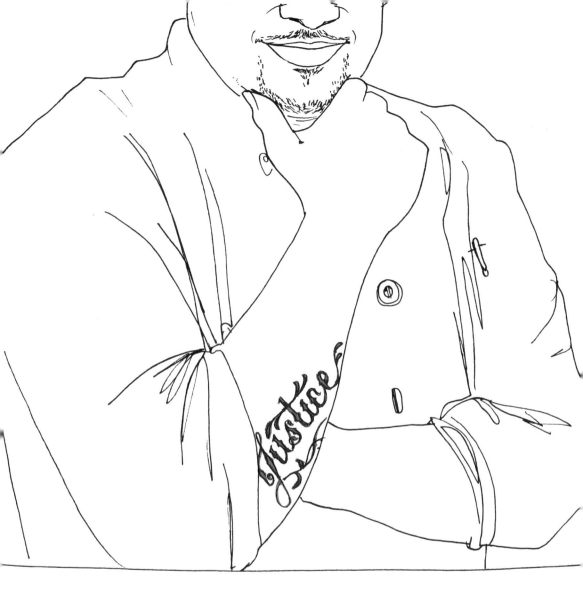

PRIVATE CHEF
LOS ANGELES, CALIFORNIA

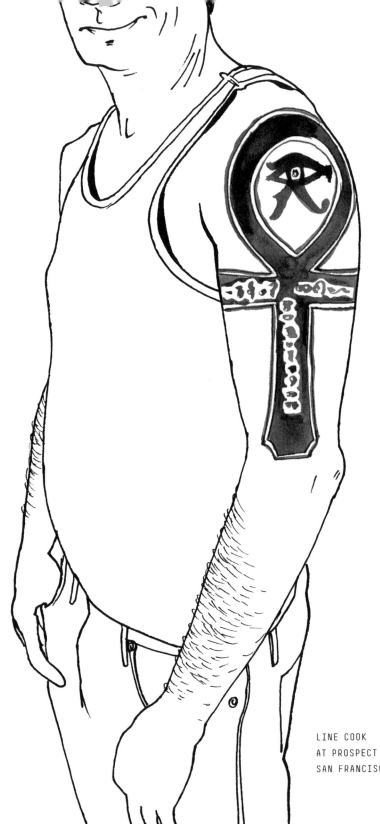

164

LINE COOK
AT PROSPECT
SAN FRANCISCO, CALIFORNIA

# MICHAEL DAVID MANN

THE EYE of HORUS WAS MY FIRST TATTOO, WHICH I GOT MORE THAN TWENTY YEARS AGO WHEN I WAS NEW TO CALIFORNIA. THE TATTOO ARTIST TOLD ME THAT I NEEDED TO DRAW MY OWN DESIGN, SO I CHOSE THE EYE of HORUS: THE SYMBOL REPRESENTS PROTECTION and GOOD HEALTH, and I'D ALWAYS BEEN INTERESTED IN ANCIENT EGYPT.

WHEN I FIRST MET JESSICA, SHE TOLD ME THAT MY EYE of HORUS TATTOO WAS WIMPY. I BELIEVED HER—AFTER ALL, I HAD DESIGNED IT, and I'M NO ARTIST. JESSICA AND I DIDN'T KNOW EACH OTHER THAT WELL, BUT SHE TOOK ME TO HER BUDDY AT LYLE TUTTLE and HAD HIM BEEF IT UP. JESSICA and I STAYED CASUAL FRIENDS UNTIL I MOVED TO FLORIDA and WE LOST TOUCH. IN 2011, I MOVED BACK TO CALIFORNIA BUT NO LONGER HAD JESSICA'S CONTACT INFORMATION.

A COUPLE YEARS LATER, A FRIEND HAPPENED TO SEE HER ON THE STREET and GOT HER NUMBER. AS CHANCE WOULD HAVE IT, HE and I HAD JUST BEEN TALKING ABOUT HER. I REACHED OUT TO JESSICA and WE MET UP FOR DRINKS. THE ATTRACTION WAS INSTANT. WE'VE BEEN TOGETHER NOW FOR TWO YEARS, and ARE GETTING MARRIED NEXT YEAR. JESSICA and I HAVE BEEN TALKING ABOUT GETTING ME A NEW TATTOO TO REPRESENT MY PASSION FOR COOKING. BUT THIS TIME, I'M GOING TO LET HER DRAW THE DESIGN.

# MICHAEL DAVID MANN'S CREAMY CAULIFLOWER SOUP

The key to this soup is to use a homemade stock. You can either use roasted chicken, turkey, or Cornish game hen to make a dark bird stock—no duck, pheasant, goose. The stock can be made well in advance and frozen.

*To make the stock, simmer the carcass in a large pot with*
1 YELLOW ONION, SLICED
2 CARROTS, SLICED
3 CELERY STALKS, SLICED
1 TABLESPOON PEPPERCORNS
3 BAY LEAVES

Once the stock has absorbed all the flavor from the carcass and vegetables, remove the vegetables and carcass and then reduce the stock down until it's very concentrated. Strain before storing.

*To make the soup, you'll need*
1 HEAD OF CAULIFLOWER, CUT INTO FLORETS
1 SLICED YELLOW ONION
3 CLOVES GARLIC
2 BAY LEAVES
SALT AND PEPPER
THE HOMEMADE STOCK
½ CUP HEAVY CREAM OR HALF & HALF
BACON
BRUSSELS SPROUT LEAVES

Cook the bacon and brussels sprout leaves in a large Dutch oven or cast-iron pot (make sure it will be large enough to hold all the stock) until crispy. Remove from the pot and set aside.

Add the onions and garlic to the pot and cook, scraping up the bottom of the pan until onion is softened. Add the stock, bay leaves, half & half (or cream), and cauliflower to the pot. Season to taste with salt and pepper. Cover and cook until cauliflower is tender.

Remove the bay leaves, then blend the soup until smooth; you can use a hand mixer or a blender. Add water if the soup is too thick. Serve with the crisp bacon and brussels sprout leaves sprinkled on top.

HOMEMADE
STOCK

# RYAN GOERGEN

IF YOU'VE EVER SEEN A PACKAGE of RED MAN CHEWING
TOBACCO, YOU MIGHT RECOGNIZE THIS IMAGE. RED
MAN WAS MY GRANDFATHER'S PREFERRED TOBACCO BRAND,
and ON OCCASION HE'D PULL THE POUCH OUT of HIS
BACK POCKET, PLACE A PINCH of CHEW IN HIS LIP, and
THEN OFFER ME SOME. HE DIDN'T ALWAYS OFFER, BUT
WHEN HE DID, I'D ACCEPT.

I WAS SOMEWHERE AROUND EIGHT TO TEN YEARS OLD
WHEN THIS TRADITION STARTED. (I DON'T WANT TO
PAINT A PICTURE of MY GRANDPA PUSHING TOBACCO
PRODUCTS ON A FIVE-YEAR-OLD.) ALMOST ALWAYS
WHEN I ACCEPTED HIS OFFER I IMMEDIATELY SPAT THE
TOBACCO OUT and WOULD WONDER HOW HE COULD
STAND THE TASTE.

EVENTUALLY I REALIZED HE WAS DOING THIS TO MAKE
SURE THAT, UNLIKE HIM, I WOULD NEVER TOUCH
CHEWING TOBACCO for THE REST of MY LIFE. AND
LET ME TELL YOU, GRANDPA WAS RIGHT.

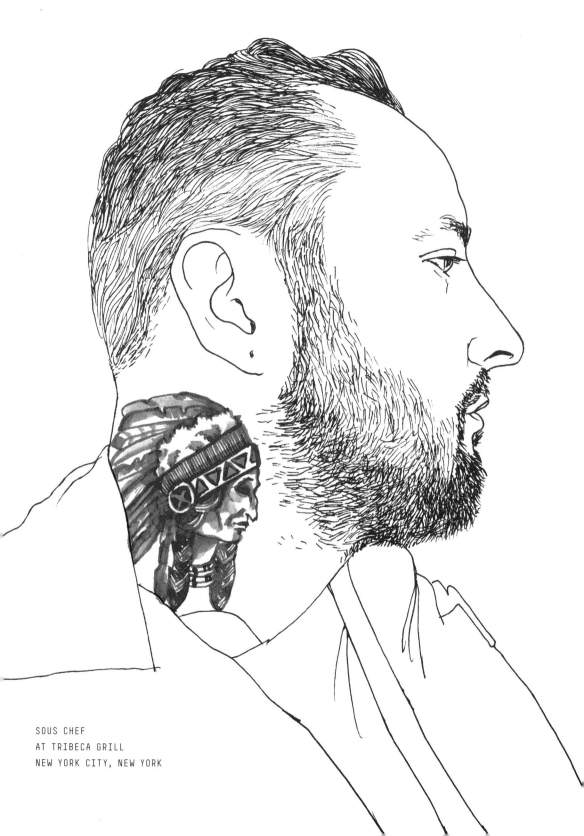

SOUS CHEF
AT TRIBECA GRILL
NEW YORK CITY, NEW YORK

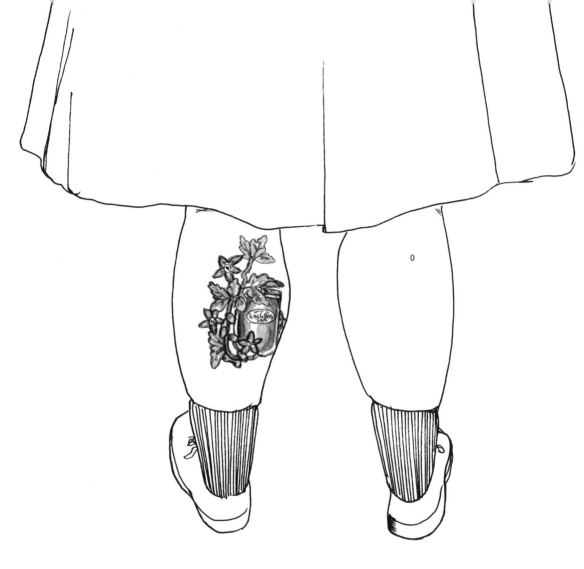

OWNER OF AND CHEF
AT SUBTERRANEAN HOMEMADE FOODS
ST. LOUIS, MISSOURI

# ROBIN WHEELER

MY GRANDMOTHER, WHO RECENTLY TURNED NINETY, STILL GARDENS and CANS WHAT SHE GROWS. I'VE MADE A CULINARY CAREER BASED ON WHAT I'VE LEARNED ABOUT FOOD PRESERVATION FROM HER, and GROWING UP IN A FAMILY THAT DIDN'T LET ANY FOOD GO TO WASTE. CELLARS FULL of FOOD IN JARS IN EVERY RELATIVE'S HOUSE. THAT WAS NORMAL TO ME.

I CHOSE GOOSEBERRIES for THE TATTOO BECAUSE THEY'RE ONE of MY FAVORITES, and I SPENT A LOT of TIME EATING RAW GOOSEBERRIES IN HER GARDEN. I'M SURPRISED EITHER of MY GRANDMOTHERS HAD ANY PRODUCE TO PUT UP, BECAUSE I GRAZED LIKE A LITTLE GOAT AT BOTH of THEIR PLACES.

TWO SUMMERS AGO I MADE GOOSEBERRY JAM for THE FIRST TIME, and IT WAS THE MOST LABOR-INTENSIVE, TIME-CONSUMING, PHYSICALLY BRUTAL FOOD I HAVE EVER MADE. PINCHING THE TINY BLOOMS and STEMS OFF EACH LITTLE BERRY LEFT MY DAUGHTER

and ME with SORES ON OUR FINGERS. IT HIT ME THAT MY GRANDMOTHER HAS ALWAYS DONE THIS, and STILL DOES THIS.

SO I SHOWED UP AT THE TATTOO PARLOR A FEW WEEKS LATER with A JAR of HER JELLY TO USE AS A MODEL. WHEN MY ARTIST WAS DONE, HE ASKED TO KEEP THE JELLY AS PART of HIS TIP.

# ROBIN WHEELER'S CHERRY BOURBON OLD-FASHIONED JAM

*Makes 6 half-pint jars*

4 CUPS PITTED SWEET CHERRIES (FRESH OR FROZEN), CHOPPED
3 TABLESPOONS FRESH-SQUEEZED ORANGE JUICE
1 TABLESPOON FRESH LEMON JUICE
1 CUP BOURBON
4 CUPS GRANULATED SUGAR
1 PACKAGE POWDERED PECTIN

In a large pot over medium heat, combine cherries, juices, and bourbon. Whisk in pectin until dissolved, and bring to a rolling boil. Add the sugar all at once, stirring to dissolve, and return to a full boil.

Boil hard—jam should reach 220° F—for 3 minutes. Remove from heat and skim off any foam. Test to make sure jam has reached the gel stage by placing a dollop of jam on a frozen plate. If the jam wrinkles when pushed, it's reached gel stage.

Ladle jam into sterilized jars, leaving 1/4-inch headspace. Wipe the jar rims with a clean, wet cloth, put lids and rings in place, and put jars in a heated hot water canner. The jars should be at least 1-inch submerged. Return water to a boil and process with the canner lid on for 10 minutes.

Remove jars from canner and let cool on a towel, allowing the jars to seal. You'll hear a ping when a seal is created. After 24 hours, make sure the button in the middle of the lid is depressed. These jars are shelf stable for one year. Any jars with a popped button should be refrigerated and consumed within 2 weeks.

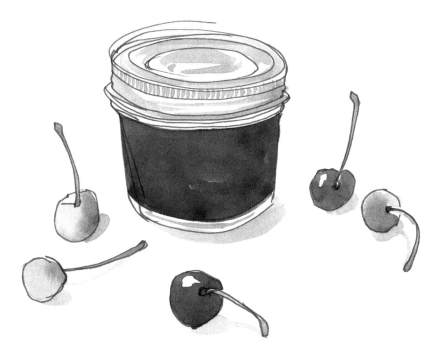

# BRIAN LIMOGES

WHEN I WAS IN CULINARY SCHOOL IN VERMONT ONE
of THE THINGS WE HAD TO DO WAS TO HELP KILL A
PIG. IT LIVED ON A SMALL FARM, WHERE A FAMILY RAISED
SWINE SOLELY for THEIR CONSUMPTION THROUGHOUT
THE YEAR. WHEN IT CAME TIME TO KILL THE PIG, ALL
of US STOOD OUTSIDE of THE PEN and WATCHED
IN HORROR AS THE CHEF AIMED HIS GUN AT POINT-
BLANK RANGE AND PULLED THE TRIGGER. THE PIG DID
NOT GO DOWN. CHAOS ENSUED and SOON WE WERE FACED
with THREE PANICKING PIGS, IDENTICAL-LOOKING,
RUNNING IN DIFFERENT DIRECTIONS. IN THE
CONFUSION, TWO PIGS WERE KILLED. THE EXPERIENCE
WAS SURREAL, BRUTAL, and HORRIFYING. BUT IT
REMINDED ME WHAT PEOPLE HAD BEEN DOING for
THOUSANDS OF YEARS. HUNTING. GATHERING. COOKING.
WE TOOK THE BELLY BACK with US and COOKED IT
THAT NIGHT. I GOT THIS TATTOO AS AN HOMAGE TO
THOSE PIGS—TO SYMBOLIZE WHAT IT MEANS for ME
TO COOK and TO BE A CHEF, and THE SACRIFICE ANIMALS
MAKE SO THAT WE CAN CONSUME THEM.

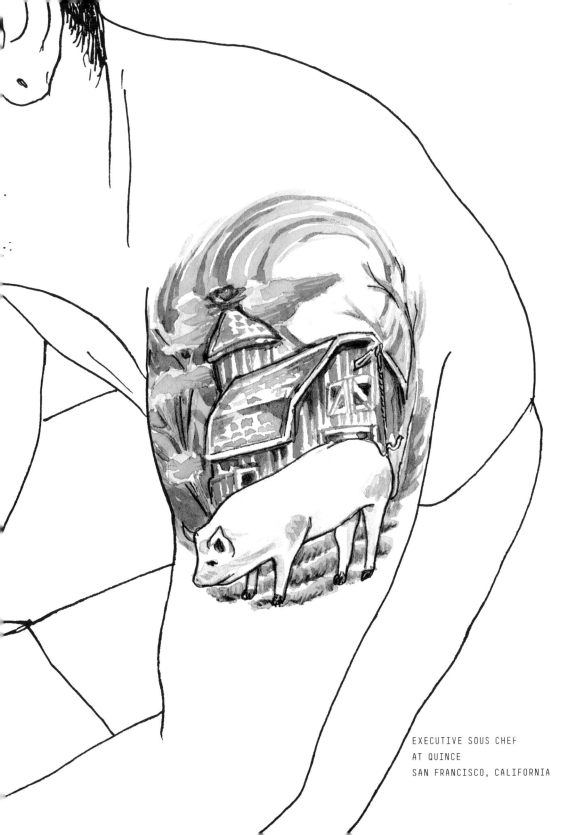

EXECUTIVE SOUS CHEF
AT QUINCE
SAN FRANCISCO, CALIFORNIA

# BRIAN LIMOGES'S PUMPKIN CUSTARD

750 GRAMS MUSQUEE DE PROVENCE PUMPKIN,
    PEELED, SEEDS REMOVED
400 GRAMS MILK
200 GRAMS CREAM
40 GRAMS BUTTER
4 GRAMS SALT

Cook down in medium-sized pan until pumpkin is tender and glazed. Blend all ingredients on high until smooth. Should be a thick-soup consistency.

13.5 GRAMS IOTA CARRAGEENAN
1.3 GRAMS GUAR GUM

While pumpkin purée is hot, add in carrageenan and guar gum and blend for 1 minute. The puree will thicken as it blends. Cool down purée.

To set the custard: heat the thick purée back up, stirring constantly. It should turn back into a thin liquid. Fill a small 4-ounce vessel about half full, tapping the bottom to make even. Cool down.

*Oat consommé gel*
1,000 GRAMS TOASTED OATS
2,000 GRAMS WATER
5 GRAMS SALT
4.5 GRAMS GOLDEN LEAF GELATIN, BLOOMED IN ICE WATER

Season the oats with the salt and cover with water. Heat up very slowly for 30 minutes. The water will absorb the flavor of oats and take on a dark color. Strain off water. Reduce until 300 grams remain. While still hot, add gelatin to oat consommé and whisk in until gelatin melts. Pour 20 grams over already-set pumpkin custard, then chill.

*To garnish*
Garnish chilled custard with toasted pumpkin seeds, mandarin segments, pumpkin oil, Pacific Plaza osetra gold caviar, and marigold flowers.

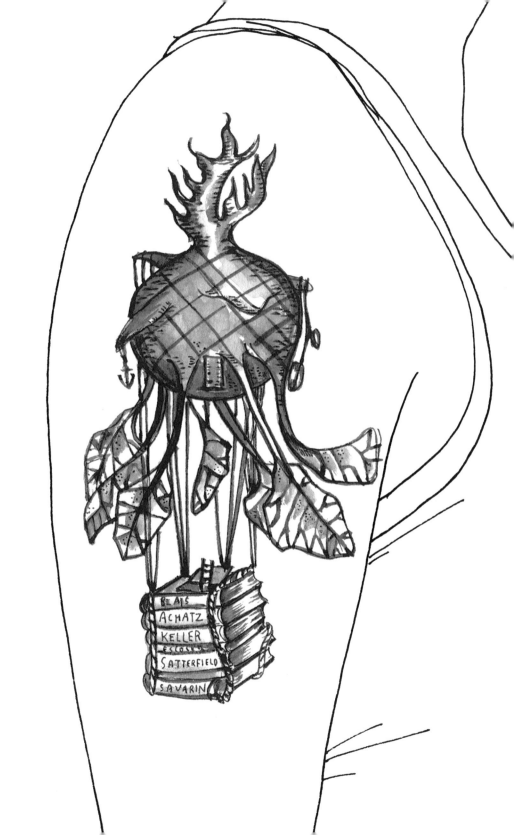

# SEAN TELO

IT'S A KOHLRABI HOT-AIR
BALLOON. THE BASKET IS MADE
of COOKBOOKS BY CHEFS
I'VE WORKED for OR ADMIRE.
WITHOUT THEM I WOULDN'T
BE ANYWHERE.

EXECUTIVE CHEF
BROOKLYN, NEW YORK

# TIM ARCHULETA

WHEN I GOT MY DRAGON TATTOO, I WAS AT A POINT IN MY LIFE WHERE I NEEDED SOME SPIRITUAL GUIDANCE. I ATTENDED CATHOLIC SCHOOL FROM KINDERGARTEN TO EIGHTH GRADE and MY RELATIONSHIP with JESUS WAS ON THE ROCKS—WELL, LET'S JUST SAY WE TEMPORARILY BROKE UP. I GOT REALLY INTO BUDDHISM, and FOUND A BEAUTIFUL DRAWING of A DRAGON ON THE INSIDE COVER of ONE of THE BOOKS I WAS STUDYING. I GOT IT TATTOOED ON MY LEFT FOREARM.

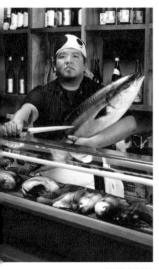

TWO YEARS LATER, I GOT THE TIGER ON MY RIGHT FOREARM TO BALANCE OUT THE DRAGON. ONE GOING DOWN, ONE COMING UP. MY WIFE CALLS THE DRAGON A "PUPPY" and THE TIGER A "KITTY"—MY PUPPY and KITTY TATTOOS.

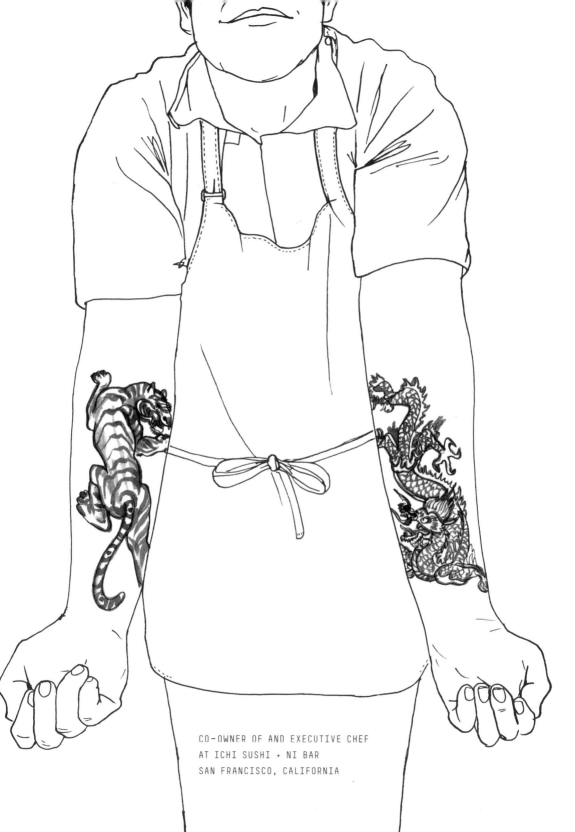

CO-OWNER OF AND EXECUTIVE CHEF
AT ICHI SUSHI + NI BAR
SAN FRANCISCO, CALIFORNIA

## TIM ARCHULETA'S SHISO PESTO SOMEN SALAD

*Serves 2*

4 OUNCES SOMEN NOODLES
5 BUNCHES SHISO LEAVES
¼ CUP GRAPESEED OIL
¼ TEASPOON SALT
¼ OUNCE YUZU JUICE
1 TABLESPOON LEMON ZEST

Bring 2 quarts heavily salted water to a boil. Add noodles and stir once, then leave to cook until al dente. Strain and then plunge into a bowl of ice water to cool. Strain again and set aside, refrigerating until use.

Combine shiso leaves, oil, and salt in a blender. Pulse until smooth. Dress noodles with shiso pesto, then mix in yuzu juice.

Serve either on plates or in a big bowl, family-style, garnished with lemon zest.

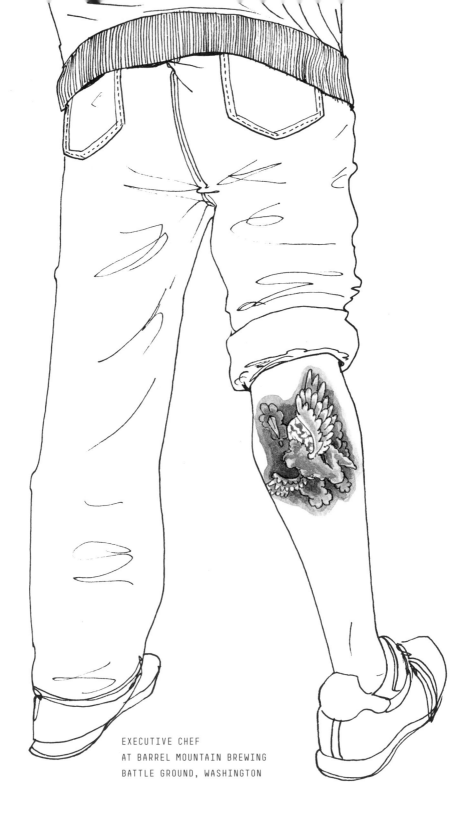

184

EXECUTIVE CHEF
AT BARREL MOUNTAIN BREWING
BATTLE GROUND, WASHINGTON

# DANIEL ROBAYO

THIS IS ACTUALLY MY FIRST TATTOO. I WAITED A LONG TIME BECAUSE I WANTED TO GET SOMETHING THAT MEANT A LOT TO ME, SO AFTER TWENTY YEARS IN THE KITCHEN I GOT A FRIED CHICKEN WING TATTOOED ON MY CALF. PEOPLE OFTEN ASK, "WHAT ABOUT WHEN YOU'RE SEVENTY and YOU HAVE A BIG-ASS CHICKEN WING FLYING THROUGH FUCKING SPACE ACROSS A BLEU CHEESE MOON LIKE SOME KIND of POULTRY-BASED E.T. ON YOUR LEG?" MY RESPONSE HAS ALWAYS BEEN, "WELL, I FUCKING LOVE CHICKEN WINGS." BUT IF I HAD TO REALLY TRY and "MAKE SENSE of THE SYMBOLISM" BEHIND IT (BECAUSE NORMALS ALWAYS WANT TO KNOW SOME DEEP STORY ABOUT WHAT IT MEANS TO ME), I FEEL IT REPRESENTS HOW WHIMSICAL and FUN I THINK FOOD CAN BE, HOW FREE IT MAKES ME FEEL. COOK HIGHBROW, EAT LOWBROW. I LOVE RUSTIC, FAMILIAR FOODS. I LOVE HOW MANY THINGS I CAN DO with SOMETHING AS SIMPLE AS A CHICKEN. AND REALLY, TO BE BRUTALLY HONEST, I THINK IT'S FUCKING COOL AS SHIT. THE WING HAS WINGS. BETTER THAN AN EX-GIRLFRIEND'S NAME ANY DAY. CHICKEN WINGS WILL NEVER LEAD ME WRONG.

# ARTISTS and PARLORS

TIM ARCHULETA, original tattoo by Colin Stevens at Body M Tattoo Annex, San Francisco, CA

RICHARD ARTEAGA, original tattoo by Daniel Guzman, Jersey City, NJ

NYANYIKA BANDA, original tattoo by Phil Szlosek at Kings Avenue Tattoo, New York City, NY

JIM BERMAN, original tattoo by Jimmy Mackey at Monster Tattoo, Newport, DE

NATE BERRIGAN-DUNLOP, original tattoo by Andy Moreno at Sacred Tattoo, Oakland, CA

JAMIE BISSONNETTE, original tattoo by Tony Ciavarro at Greenman Tattoo, West Hartford, CT

MARK CRUZ, original tattoo by Marco at Picture Machine, San Francisco, CA

BRANT DADALEARES, original tattoo by Wilhelm Scherer at Sanctuary Tattoo, Portland, ME

JEREMIAH TODD DeBRIE, original tattoo by Ben Pease at Pino Brothers Ink, Cambridge, MA

JENNY DORSEY, original tattoo at East Side Ink, New York City, NY

AMANDA DOWNING, original tattoo by Tattoo Factory, Chicago, IL

CATHERINE DOYLE, original tattoo by Milton Cardenas at Tattoo Royale, San Diego, CA

JOEY DUNSCOMBE, original tattoo by Josh at Steve's Tattoo, Madison, WI

ERIC C. EHLER, original tattoo by Soul Patch, San Francisco, CA (closed)

MARIELLE FABIE, original tattoo by Rangoon Ricky at Only Skin Deep, Vallejo, CA

ALISA FRALOVA, original tattoo by Robert Bonhomme at Brooklyn Tattoo, Brooklyn, NY

RYAN GOERGEN, original tattoo by Bill Blood at Ace of Hearts Tattoo, San Pedro, CA

MYSTICAL GREATRICK, original tattoo by Candi at Tuesday Tattoo, San Francisco, CA

BRIAN GROSZ, original tattoo by Mike Rubendall at Kings Avenue Tattoo, New York City, NY

JOEL HARRIS, original tattoo by Hobo's Tattoo, Portsmouth, NH

WILLIAM J. HASKINS, original tattoo by Randy at Modern Tattoo, North Chicago, IL

SOLEIL HO, original tattoo by Brooke Michael Englehart at Delicious Ink, Rockford, IL

CLINT IVES, original tattoo by Rob Ryan at Electric Tattoo, Asbury Park, NJ

MONICA LO, original tattoo by Gitte Klebajn at Le Fix Tattoo, Copenhagen, Denmark

LAUREN MACELLARO, original tattoo by Jeremy Joachim at Hot Stuff Tattoo, Asheville, NC

MICHAEL DAVID MANN, original tattoo by Bryan Taylor at Lyle Tuttle Tattooing, San Francisco, CA

ANGIE MAR, original tattoo by Amy Shapiro at Three Kings Tattoo, Brooklyn, NY

MATT MARCHESE, original tattoo by John Reardon at Greenpoint Tattoo Co., Brooklyn, NY

DONNIE MASTERTON, original tattoo by Ruben Martinez Munoz at Tinta y Rock Tattoos, San Miguel de Allende, Mexico

ALEX McCRERY, original tattoo by Michelle Tarantelli at Saved Tattoo, Brooklyn, NY

TRAVIS MILTON, original tattoo by Ash Swain at Cool Hand Tattoo, Richmond, VA

RIC ORLANDO, original tattoo by Damien Bart at Bruce Bart Tattoo, Fort Lauderdale, FL ("Though he did it in my kitchen in Woodstock.")

SEAN PACKAN, original tattoo by Rich Cahill at Rich Cahill Studios, Frenchtown, NJ

JOE PALMA, original tattoo by Eddie at Tattoo Alley, Queens, NY

JENNIFER LYN PARKINSON, original tattoo by Angel at Lady Luck Tattoo (design) and Patrick at Shamrock Tattoo (coloring), Spokane, WA

NICHOLAS PORCELLI, original tattoo by Big Steve Pedone, Fun City Tattoo, New York City, NY

JOHN PRESCOTT, original tattoo by Bobby Padron at Rock of Ages Tattoo, Austin, TX

MICHELLE PUSATERI, original tattoo by Cecila Altamirano at Seventh Son Tattoo, San Francisco, CA

DANIEL ROBAYO, original tattoo by Johnny Lightning at Hopeless Ink Tattoo, Vancouver, WA

ALEC SHERMAN, original tattoo by Marshall Brown at Brown Brothers Tattoo, Chicago, IL

ANTHONY STRONG, original tattoo by Jeff Rasier at Blackheart Tattoo, San Francisco, CA

SEAN TELO, original tattoo by Pete Kendrick at Daredevil Tattoo,
New York City, NY

DANIEL FRANCIS TOWER, original tattoo by J. Ranno at Mom's Tattoo
Studio, Amherst, MA

ROZE TRAORE, original tattoo by Ross Ferrie at Acme Tattoo,
Portland, OR

ALDEN ULERY, original tattoo by Steve Minerva at Hidden History,
Dover, NH

NICK VENEZIA, original tattoo by Elvis at Ink City Tattoo, Trenton, NJ

TRAVIS MICHAEL WEISS, original tattoo by David Cavalcante at Tattoo
Paradise, Washington, D.C.

ROBIN WHEELER, original tattoo by Phil Duple at Iron Tiger,
Columbia, MO

DEVIN WHITE, original tattoo by Asa Larson at American Tattoo,
Omaha, NE

BRAXTON YOUNTS, original tattoo by Randy Herring at Skin Art,
Gastonia, NC

" WELL, THAT WAS GOOD. "

# ACKNOWLEDGMENTS

The authors would like to pile heaps of thanks onto Nancy Miller for her editorial prowess, encouragement, and kind, everlasting patience. Without Nancy this beautiful book would be nothing more than an idea scribbled on a scrap of paper covered in coffee and beer stains, abandoned on a bar in San Francisco. Many thanks to Patti Ratchford, whose graphic guidance helped this project become the beautiful book we'd dreamed it to be. Thank you to Katya Mezhibovskaya, whose incredible design skill is the only thing sharper than her eye, who spun a majestic, solid-gold book design out of the loose straw we gave her. And to Laura Phillips, who managed to keep all of our trains running on time, even when there were no trains to speak of. Many thanks to Karen Leibowitz and Liz Crain for connecting us with spectacular chefs from all over the country. Thanks to Cliff Shapiro for his wonderful photos, one of which was the basis for the cover of this book, and to all of the chefs who provided us with fantastic photos. And extra special thanks to our tireless agent, Charlotte Sheedy, who may just be a real-life saint. Lastly, we give our heartfelt, gigantic appreciation to all of the chefs, both those who are in this book and those who submitted their tattoos to this project. Without you, chefs, this project is nothing. Thank you.

ISAAC FITZGERALD HAS BEEN A FIREFIGHTER, WORKED ON A BOAT, and WAS ONCE GIVEN A SWORD BY A KING, THEREBY ACCOMPLISHING THREE OUT of FIVE of HIS CHILDHOOD GOALS. HE IS EDITOR OF BUZZFEED BOOKS and CO-AUTHOR OF PEN & INK, and LIVES IN NEW YORK CITY.

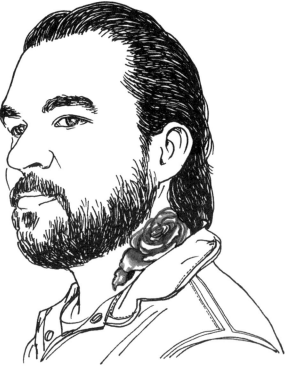

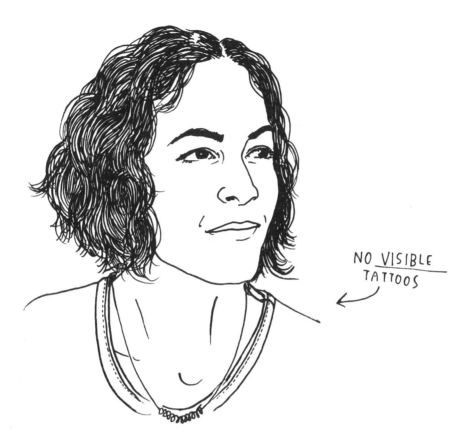

NO VISIBLE TATTOOS

WENDY MACNAUGHTON IS A NEW YORK TIMES BESTSELLING ILLUSTRATOR WHOSE BOOKS INCLUDE PEN & INK, LOST CAT, MEANWHILE IN SAN FRANCISCO, and THE GUTSY GIRL. HER WORK HAS APPEARED IN PLACES SUCH AS THE NEW YORK TIMES, BON APPÉTIT, and LUCKY PEACH. SHE LIVES IN SAN FRANCISCO.